PAINTING LANDSCAPES IN PASTEL

PAINTING LANDSCAPES IN PASTEL

By Ernest Savage

WATSON-GUPTILL PUBLICATIONS/NEW YORK

PITMAN PUBLISHING/LONDON

To Marjorie, My Devoted Wife

First published 1971 in the United States and Canada by Watson-Guptill Publications,
a division of Billboard Publications, Inc.,
One Astor Plaza, New York, N.Y. 10036
ISBN 0-8230-2610-8
Library of Congress Catalog Card Number: 76-154027

Published in Great Britain 1974 by Sir Isaac Pitman & Sons Ltd.,
39 Parker Street, Kingsway, London WC2B 5PB
ISBN 0-273-31871-3

Manufactured in U.S.A.

First Printing, 1971
Second Printing, 1972
Third Printing, 1974

Acknowledgments

For the completion of this, my fourth work on the pastel medium, I owe a great deal to the encouragement of my friends and pupils, but most to the sustaining devotion of my wife Marjorie. Hers was the slog of typing and proofing, coupled with being the provider of my daily needs.

Special thanks are due to Donald Holden, of Watson-Guptill Publications, for his dynamic inspiration, advice, and assistance, quite apart from a delightful salmon lunch at Overton's, London, where we first met for a heads-down discussion.

Then there are my friends at the Pitman Correspondence College to whom appreciative thanks are extended, especially to Robert Light, B.S., F.C.I.S., M.B.I.M., and Derek Beattie, T.D., B.A., former and present principals of the college, for permission to use certain illustrative material from the *Ernest Savage Home Study Pastel Course*, which is acknowledged where used in the book.

The quality· of the reproduction of my original drawings and paintings is due to the expertise of William Mackley, of Bramley, whose photographic sessions on many occasions extended to all hours.

To all these, and to those private collectors who kindly allowed me the use of my work in their possession, go my sincere thanks.

Fittleworth 1970

Color Plates

Contents

Foreword

As president of the Pastel Society of Great Britain, I take very great pleasure indeed in writing a foreword for this delightful book on pastel by Ernest Savage. He is not only a valued member of the society and a great personal friend and colleague, but also an acknowledged expert in the art of teaching.

If a greater understanding and appreciation of the medium is the only accomplishment secured by this volume, it will have rendered sterling service. I am convinced, however, that many will be encouraged to try this beautiful and fascinating method of portraying the wonders of nature. A cursory glance at the many illustrations in color will be sufficient to spur the reader on, confident in the knowledge that the guiding hand is that of an artist and teacher of outstanding ability.

For those to whom pastel is no stranger, there is much that is invaluable and instructive in the following pages, and I trust the stimulus provided will encourage the greater use of this lovely medium.

I know that many will be introduced to the pleasure of pastel painting for the first time in a most convincing and friendly way. It will, I am sure, give endless enjoyment such as that experienced by the author and myself over a period of many years.

I wish both this book and you, its reader, every success.

Aubrey Sykes, VPRI, PPS.

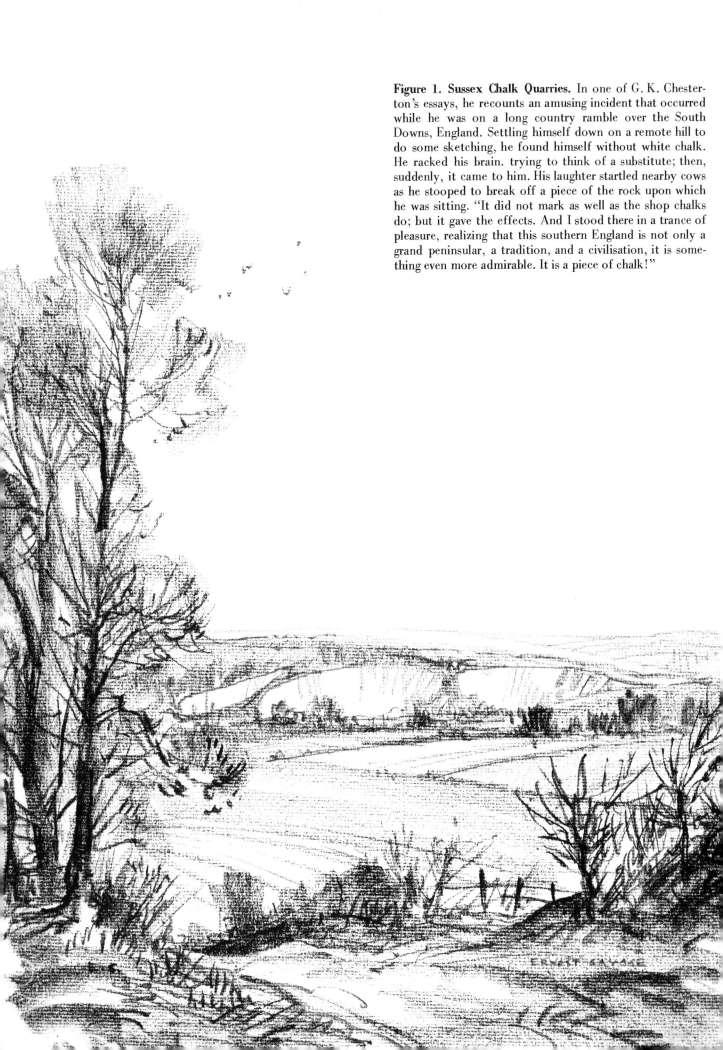

Figure 1. Sussex Chalk Quarries. In one of G. K. Chesterton's essays, he recounts an amusing incident that occurred while he was on a long country ramble over the South Downs, England. Settling himself down on a remote hill to do some sketching, he found himself without white chalk. He racked his brain. trying to think of a substitute; then, suddenly, it came to him. His laughter startled nearby cows as he stooped to break off a piece of the rock upon which he was sitting. "It did not mark as well as the shop chalks do; but it gave the effects. And I stood there in a trance of pleasure, realizing that this southern England is not only a grand peninsular, a tradition, and a civilisation, it is something even more admirable. It is a piece of chalk!"

Preface

There's something rather special about working with pastel. Its technical quality has such unique charm (*Figure 1*). Pastel is adaptable to any kind of subject matter, and there's an ease of responsiveness in the pastels themselves that makes even a beginner's progress quite rapid. If you're trying pastel for the first time, you'll soon begin to appreciate the scope of this delightful medium, and feel the exhilaration and the excited expectancy of being able to break into a new field of visual expression. The masterpiece seems to be just around the corner, so to speak. In other spheres of activity, I suppose this excitement—which stirs hope and desire for achievement—compares with catching your first fish or with sampling that first dish from a gourmet's cookbook or even to the first weightless twirl in a space capsule. The delight is such that you want much more of it.

This just about sums up the aim of this book and my own approach in helping you; it's really to whet your appetite for pasteling. I hope you'll be captivated by this fascinating medium and want more and more experience of it.

However, in their different ways, the fisherman, chef, and astronaut devotedly study their pursuits to various degrees before they reach a state of pleasurable achievement. The common factor in all three cases is the sustained effort that each puts into his activity. I want to nourish your enthusiasm with my knowledge and experience. In this book, all the methods, processes, and techniques of pasteling will be explained gradually. With this concise information, you'll have a solid groundwork on which to build your experiments in this unique way of expressing yourself pictorially.

Make no mistake about it, pastel is just as efficient, complete, and traditional a medium for painting permanently lasting pictures as oil or watercolor. Remember, it wasn't so long ago that watercolor was generally considered to be a medium only Sunday painters used. Just think how the wizards of watercolor have put this medium on the map. So don't be put off by the oft repeated misconception that work in pastel is fragile and impermanent. In fact, of all the media at our disposal, pastel is the easiest to preserve and protect. Oils darken, watercolors fade, but pastels last forever!

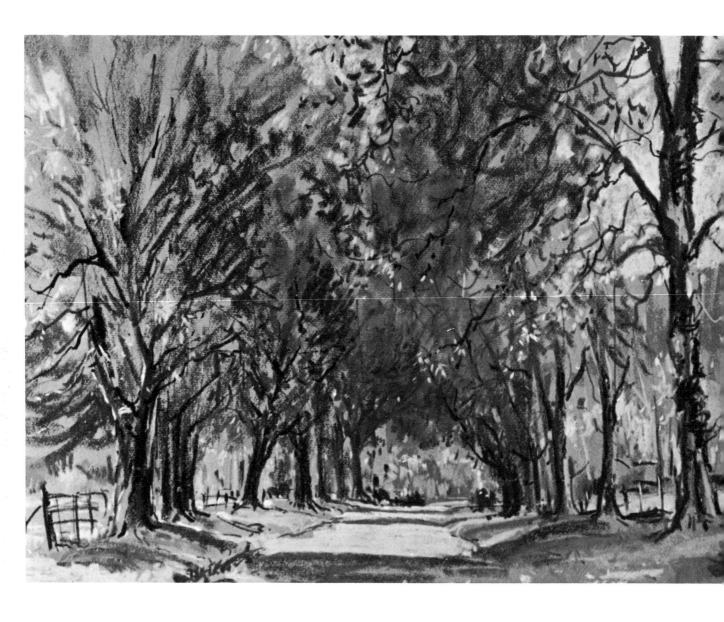

Figure 2. Chestnut Avenue, 22" x 30", private collection. This painting was a class demonstration, and despite its full imperial size, was completed in just over an hour. I wanted to show how a subject like this could be built up with pastel by visualizing from the start what use was to be made of a mid-gray paper for the more distant foliage values and of the introduction of the purple-gray color into the area beyond the trees. I quickly drew in the composition with a gray chalk. After this, I started to suggest the high value of the light of the sky seen through the trees and the purple-gray of the distant landscape referred to above. Then with broad sweeps of light pastel, I brought up the sunshine on road and fields. As a result, in minutes I obtained a fair statement of values prior to establishing the receding darks of the trees. Thus I was able to give the nearer trees a more contrasting treatment.

The color in the pastel pictures by the Old Masters is as fresh as the day it was applied, several centuries ago. Even with rough or careless use, pastel pictures have remarkable resistance. Should they suffer accidental damage, repair is far simpler than for any other medium.

Whenever I give a public demonstration of pastel painting (*Figure 2*), it's a sure bet that one dear old soul will exclaim, "But won't the pastel fall off before you frame it?" I then go through the dramatic routine of banging my pastel demonstration on the floor. And I tell the story about the occasion when I put a pastel picture in a bath of water. Naturally, I lost some of the pastel in both cases, but who cares? It's simple enough to touch up a pastel picture again, even after the most dreadful knocks or smudges. Later, I'll explain how.

One of my jobs is tutoring a home study correspondence course on pastel painting that truly extends all over the world. I have pupils throughout America, in Canada, Britain, France, Germany, Finland, South Africa, Australia, Malay, Singapore, and Fiji, to name a few. They all send me their pastel work rolled in tubes. Often, my own demonstration studies go backwards and forwards across the world several times. It's surely of some significance that none of this pastel work has come to any harm in the mail.

But let's consider the limitless possibilities of pastel for visual expression by artists who want their work to be traditional or modern. You'll soon discover that there's great variety in the way pastels can be applied and many different methods of approach. Pastel is excellent both for the rushed study—to record a transient effect of nature—and for working on a well-planned, highly finished studio picture. Artists like pastel because of the bold, free way in which it can be used (*Figure 3*). When working in the direct techniques, it's splendidly adaptable for contemporary work. It's a medium to fall back upon if your work in other media has got somewhat frayed at the edges. It's always a refreshing experience to work in pastel: the knife painter in oils or acrylics will find it helpful, and it will broaden the style of the watercolorist.

Have I convinced you of the exciting possibilities of using pastel? Just think of it: for a comparatively small outlay, you can make a start, get the feel of it, and as your interest develops, extend your supplies and go for pastel in a big way. Here's where this book will be of great use to you, whether you want a brief encounter or really want to devote yourself to serious study. Even the busy professional artist can use this book for complete, up-to-date reference.

Landscape painting in pastel is a joy. Share this enjoyment with me, as you read and work through this book. It's arranged for your easy reference, in distinct parts which deal with materials, methods, and techniques. There's a specially designed teaching section, too, which analyses the main components of landscape and builds up to a number of step-by-step pastel demonstrations.

So now let's discover as much as we can about the tools for the pastelist, the immense variety of lovely materials we can use, and the way to become sufficiently equipped to delve into the fascination of pastels.

Figure 3. This quick sketch of a village street was done boldly and freely with a Conté crayon. It captured the quiet atmosphere and might later be used as a basis for a more finished picture.

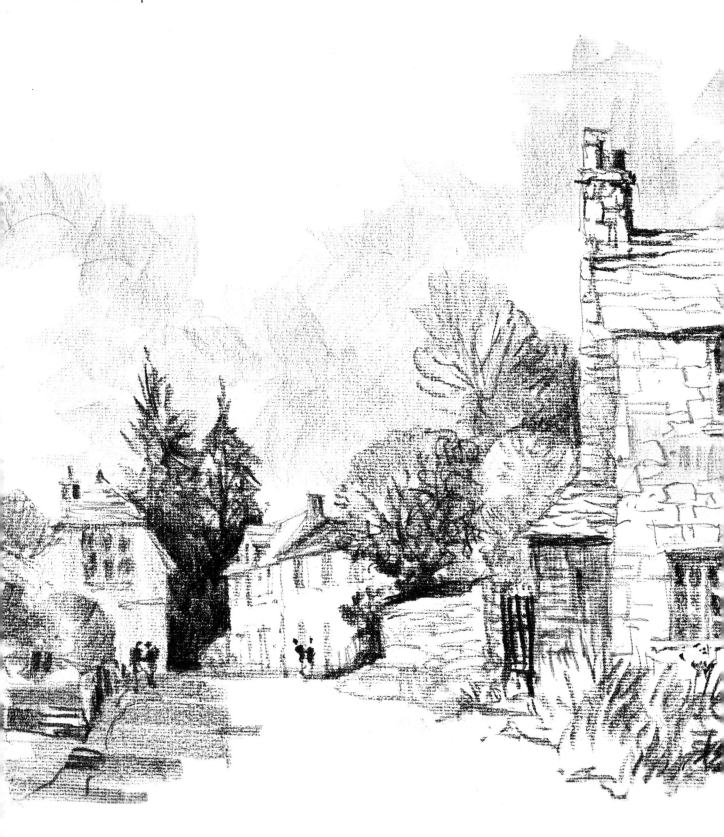

1. Beginner's Needs

Are you a compulsive shopper? I am. As soon as I spot an art material store, my defenses are down, and the salesman faces a pushover. I show a little more independence with a saleswoman, but this cannot be attributed to a deep-down interest in art. Anyhow, I invariably succumb to temptation, and stagger out of the store with an armful of exciting things. So, although I have to admit that I don't always practice what I preach, what follows is sound advice.

Buying materials

The acquisition of a storehouse of materials and a library of "how to" books won't turn you into an artist overnight. The degree of progress you make will be relative to the volume of hard, consistent work you put into the use of simple materials. If you're one of those lucky people who find great joy in constant endeavor, you're likely to succeed in whatever pursuit you first select. Regrettably, most of us need some discipline, but we're moved to improve our work output with a little encouragement. And that's what I intend to give you.

The essential requirements for the painter in any medium, apart from a willingness to work and experiment, are generally few. It's said that Sotheby's (the great London auction house) once sold a scrappy chalk drawing on what might have been the back of a grocery bill for an enormous sum. It was, of course, the work of an Old Master. This doesn't mean you have to start searching through the household accounts for suitable surfaces upon which to begin your pasteling. However, it's actually quite proper, if you're a complete beginner, to play around with pieces of pastel on any rough textured paper you can lay your hands upon.

The artist today is extremely well served with a variety of quality art products that are manufactured all over the world. But the inexperienced will need a guide in order to equip themselves with the kind of materials most likely to secure the best and quickest progress. It goes without saying that it's always best to buy the best. Yet most of us are limited to what we can afford, so I shall

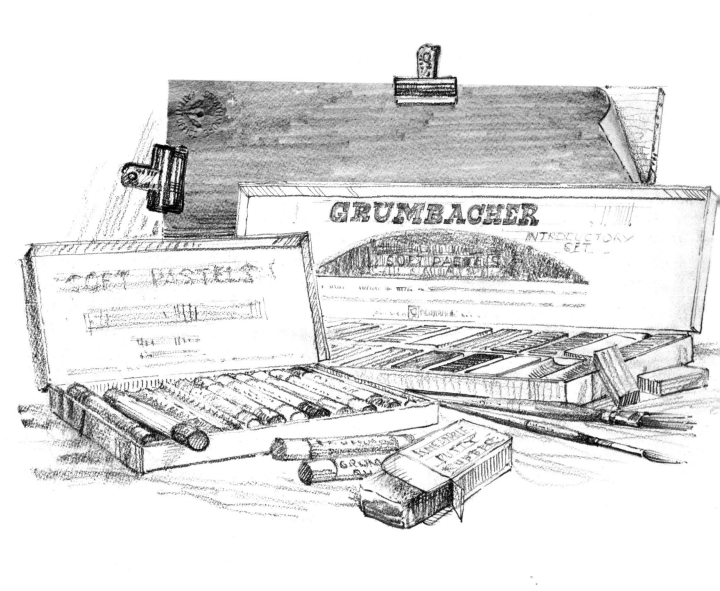

Figure 4. A beginner can make a good start with a small box of assorted soft pastels, a board, paper, spring clips, a stiff brush to sweep off pastel errors, and a kneaded putty eraser.

begin by suggesting that you purchase a few basic materials that will allow you to make a satisfactory start. Later, I'll give an exhaustive survey of all the materials and equipment likely to be required by the serious pastelist. You can then make your own choice, depending upon the kind of work that interests you, and the depth to which you want to carry your studies. But make no mistake, the more you know about the materials that are available and that you're likely to use, the better it will be for your pictorial work as a whole.

Essential needs for the beginner

You can make an excellent start with pastels for an outlay of less than five dollars—or, in Great Britain, a couple of pounds (*Figure 4*). For this sum, you can buy enough basic materials to last you for many months. In fact, equipped with these materials, it would be possible to produce pictures of exhibition quality. However, if your output of work is very great, you may need to supplement your original purchases with some extra sheets of paper.

Your initial supply of the pastels should last at least one year, unless you're going to execute your pictures on the sidewalk, when you'll find the rate of wear on your pastels is very high! So, if you're not a graffiti exponent, and if you can prevent your family from treading on your pastels, your initial supply will give you good service.

All the pastels you'll need to begin with are the following: A box of 12 to 24 assorted artists' soft pastels, which would include black and white, or the box of 30 half pastels I'll describe later. Also, a box of soft layout chalks in a series of graduated light to dark tones of gray. You see, at this stage, color isn't as important as you think (*Figure 5*).

You'll need some sheets of charcoal paper, preferably of a middle tone—that is to say, halfway between white and black—and of a neutral color like pottery green, cadet blue, velvet gray, or storm gray. These papers are made by the Strathmore Paper Company. Sheets of gray, blue-gray, purple-gray, or brown papers will also serve well; these are the Canson (French) Ingres papers.

Fix yourself up with a smooth board, Masonite or something similar, about 12½″ x 19″. This size very conveniently carries half sheets of the papers just mentioned. Use a few spring clips or Scotch tape to hold the paper to the board.

Get a cheap bristle (hog hair) oil painting brush around size 8, or use one you already have. If there's nothing else around, an old toothbrush will do. You may wonder why a brush is needed at all, but as you'll learn later, it's very useful for correcting. You'll also need a kneaded eraser (called putty rubber in Britain).

If you're a beginner with pastel, get the above materials now! Skip the next chapter or two that deal more thoroughly with materials for the most advanced pastel artist, and jump straight into the stroke practice drills and other starting techniques. When you're thoroughly absorbed in pasteling, you can return to this point to make a detailed study and buy more equipment.

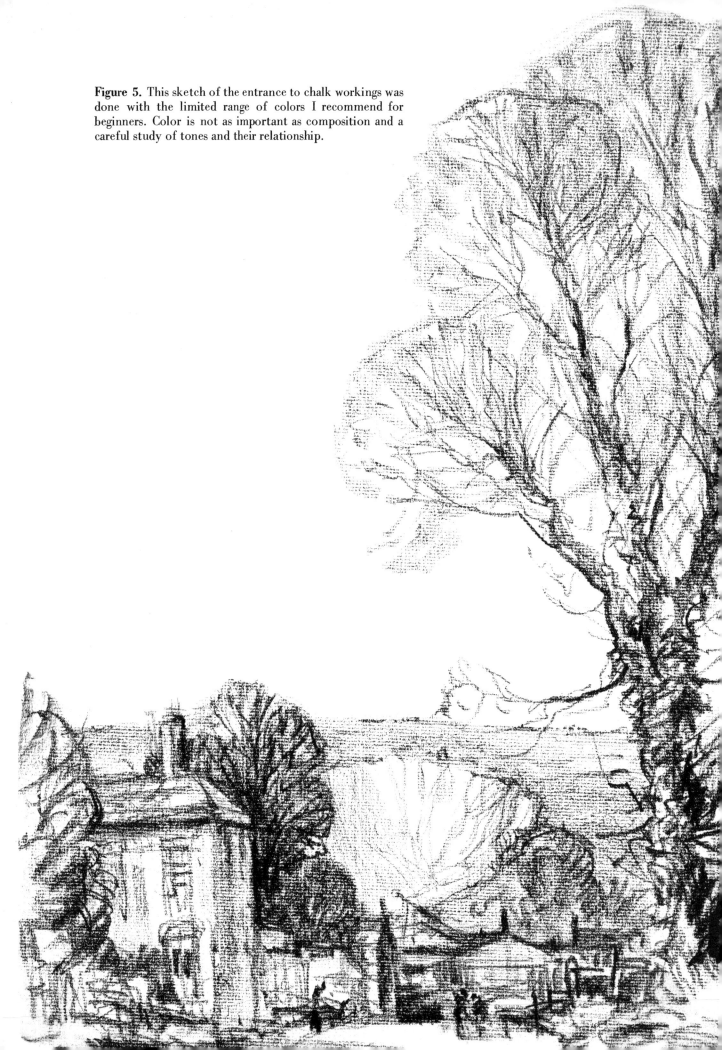

Figure 5. This sketch of the entrance to chalk workings was done with the limited range of colors I recommend for beginners. Color is not as important as composition and a careful study of tones and their relationship.

2. Pastels

Pastel is one of the three main media traditionally used by practicing artists for painting. It's a dry method of applying pigment on the surface to be painted, whereas oil and watercolor painting are wet methods. The pigment used in the preparation of all three media is precisely the same. Quality pigments with a high degree of permanence and durability are finely ground in large milling machines. Pastels, oils, and watercolors are made from these superfine, pure colors, each by a different process.

Composition of pastel

Pastels are made by regrinding these finely ground, pure colors with a mixture of chalk, clay, and a varying degree of a binding ingredient. The binder determines whether the pastel will be soft or hard. All the components are dampened and then extruded under pressure by machines somewhat similar to those used in the manufacture of lipstick. The colored wormlike length of damp pastel is collected on trays as it emerges from the machine, cut to the size required, and allowed to dry. Each stick is then labeled by hand, and boxed.

Artists' soft pastel

It's the soft pastel that's most universally used for painting pictures. The lovely velvetlike bloom that characterizes good work in soft pastel is the most sought-after texture. Its expressive quality is beloved by artists. Soft pastels break very easily, and this is a factor that must be accepted by the user. They're made almost exclusively in round sticks. An exception to this, of great importance to you, is the half sticks of soft pastel made in small rectangular pieces about 1½″ long by Grumbacher. These are packaged in an excellent, inexpensive introductory assorted set, which is my favorite among the small boxed assortments put out by the world's leading pastel makers. The little blocks of soft pastel are really delightful to use. You don't have to unwrap them; thus they are truly "instant" colors.

Hard pastels

The hard and semihard pastels are square sticks of colored chalks, and their consistency makes them suitable for the detail required in general graphic work. These pastels can be used in two ways: the broken, or sometimes sharpened, end of the stick is excellent for making fine lines, while the side of the stick can be used to quickly produce areas of tone. They are also handy for a variety of visual layout work, for rapid sketching, and in combination with soft pastels. These hard pastels are similar to Conté crayons (chalk crayons made of compressed pigment) and can be used in much the same way (*Figure 6*).

The basic technical difference between soft and hard pastels is that the former is used for pastel painting and the latter for drawing.

Color strength of soft pastels

The color strength of soft pastels is controlled by the amount of chalk, etc., which is mixed with the pure color. The lightest value, or tone, of a color contains the most chalk. Because chalk is generally less expensive than pure pigment, the lighter pastels are usually cheaper. Just as the pure pigment can be progressively lightened with fixed percentages of white chalk, it can be darkened with gradated percentages of black, thus creating a series of shades of the original color.

Range of pastels

Most pastel-manufacturing colormen have a stock of about 60 to 80 pure pigments; from each of these they make a series of tones, or values, ranging from the lightest to the darkest tint. Most make from six to eight tones for each pure pigment, so you can see what an enormous range there can be in a maker's complete assortment of tints and their shades—from as many as 400 to 600 different tinted pastels. But don't be alarmed; the average user isn't likely to need more than 100 or so. However, the availability of such an extensive assortment is important. Being able to dip at will into this large number of tints helps you to maintain a crisp vitality in your work. It also allows you to choose the kind of individual palette that suits your taste and color preferences, and contributes to the development of your own particular style.

A few years ago some makers had assortments of nearly 1,000 different pastels. But recently the most important of the world's pastel makers have reduced the efficacy of their ranges. In most instances, only the tints that were almost exactly similar to others have been excluded. If anything, the ranges are now more efficiently organized, though I was sorry to see the passing of some of the lovely names given to pastels. Mr. Sprinck's russet and Mr. Sprinck's citron were killed off by some technician in the Rowney laboratory; I suppose they were buried under the "burnt green earth" which is no longer in the Talens range.

Figure 6. A winter landscape done on the spot with a Conté crayon. This type of sketching promotes skill and experience. Notice how the Conté is used at varying pressures to depict changes in tonal value. I'm rather lucky with deer—except when they plunder my studio garden for rosebuds, which Mother Deer considers highly nutritious.

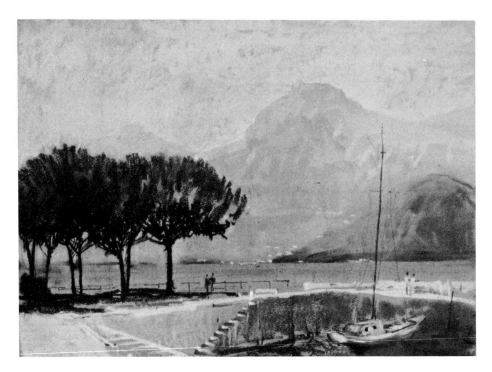

Figure 7. Lake Como, Italy, 12½″ x 19″, Collection George Addison. This little picture was completed on the spot. Attracted by the dark group of cypress trees against the distant mountain mass, and the conveniently placed boat and wall to balance my composition, I began the sky and mountain tones. I then registered the hot Mediterranean sun lighting the foreground paving, and went directly for the darks in the tree group. It was the simplicity of portrayal that paid off here.

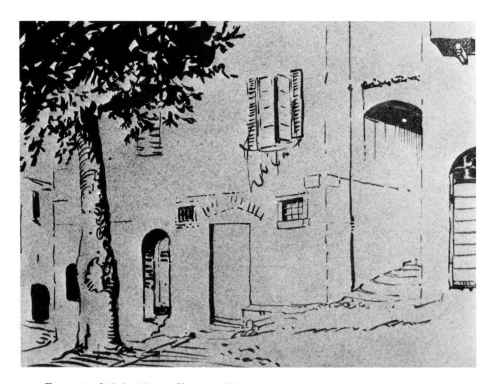

Figure 8. Old buildings, Varenna. Here's an opportunity for the inexperienced to practice pasteling on this subject. Draw it at least three times the size of the illustration, which is a brown ink brush drawing on light gray charcoal paper. Try to imagine the sun beating down on the old brick and stone walls and remember to put the wall of the stepped alley in shade. Work to make the plane tree stand out well and throw a tree shadow across the path.

Manufacturers' tint numbers explained

Unfortunately there's no worldwide standard for naming and numbering pastel colors. Each maker has his own system, and you must get to know it by getting a list of the complete range of the make sold by your art material store. I've included the complete ranges of two international pastel makers in the Appendix. It's essential to know the way a maker classifies his gradated values for each color, especially with respect to the brand that you're likely to buy.

The whole range of any one brand of pastels is rarely available for purchase; there are always some colors out of stock. This is because the expensive machinery used by the manufacturer can make pastels of only one color at a time. The machine has to be thoroughly cleaned before the next batch can be made, so it takes a long time to produce a whole range. You might often have to accept the next tone—a lighter or darker shade than the one you originally wanted. For this reason, you must know the way the series is numbered or lettered to signify the lightening or darkening of the colors. You'll probably be using the soft pastels made by M. Grumbacher, or the Rembrandt range, which originated in Holland and is marketed by Talens and Sons, Inc. (*Figures 7 and 8*). Both are of the finest quality; and to make things easy for you, this book is written around and illustrated with paintings in the excellent soft pastels produced by these two manufacturers. Of course, there are other brands with which I'm familiar, and which are just as good in quality and reliability—those made by George Rowney in Great Britain, and Lefranc in France, for example.

Both Grumbacher and Rembrandt pastels are classified by a similar method. In both ranges the pure pigment is lightened in four steps with white, and darkened in two steps with black, making a series of seven tints for each color. Each manufacturer has his own, (a) color reference number, (b) tint reference letter (Grumbacher), or decimal number (Talens), and (c) group price code, so that the cost of the stick can be seen at a glance. (The price of a stick pastel, like that of a tube of oil or watercolor, depends on the cost of the pigment used to make it.) I'm going to show you the classification for one color, burnt sienna, so that you can see how it works for these two brands of pastel.

BURNT SIENNA

Color reference no.	Grumbacher 26	Talens 411 (since 1970)
With 40% black	26-A. Gr. 1	411.3 Gr. A
With 15% black	26-C. Gr. 1	411.4 Gr. A
Pure color	26-D. Gr. 1	411.5 Gr. A
With 15% white	26-F. Gr. 1	411.6 Gr. A
With 40% white	26 H. Gr. 1	411.7 Gr. A
With 60% white	26 K. Gr. 1	411.8 Gr. A
With 80% white	26 M. Gr. 1	411.9 Gr. A

Price group: Gr. 1 = Group A

Boxed assortments of pastels

All pastel manufacturers package their products attractively and box them in sets of from 12 to 270 sticks. Any of these assortments are convenient for a start. They cost from about $3.00 for a box of 24 to about $40.00 for a box of 270. Some assortments are prepared for special purposes, such as landscape, portrait, or general design work, or a combination of all three. Since we're concerned chiefly with landscape painting in pastel, we shall be working mainly with the soft pastel assortment.

The serious landscape pastelist would do well to start with a box of about 90. He can add some extra colors to this assortment as he needs to, buying them separately. You'll be quick to discover that manufacturers' assortments never include enough of the gray and neutral tints that are a must for landscape work. The boxed assortments are always overloaded with bright colors. A manufacturer once told me that he did this because the box looked better on the shelf! There's nothing we can do about today's production managers telling us artists what we need.

Fortunately, working in pastel allows us to choose our own special colors later. But there's a problem here, too: many art suppliers are not very willing to tie up their cash by stocking half a dozen each of a maker's full range. It means that they have to get almost 3,000 pastels merely to make sure that a particular person can drop in and buy one stick of, for example, burnt sienna, tint F. I'm sure this is the real reason why pastel isn't being more universally used. So will you do this lovely medium a favor and join in the outcry for a mail-order service of single sticks of pastel from the manufacturer? You won't have to do this, of course, if you can persuade local suppliers to keep adequate stocks of them.

Tonal sets of pastel

You're never likely to get a full range of tone values in any one color in a boxed assortment. However, you'll find that your color and tonal work will become infinitely more subtle if you experiment with a whole series of seven tones in certain colors. It's most valuable, for instance, to have a set of gradated grays. Grumbacher makes a fine enlarged series of gray soft pastel in eleven gradations from dark to light. When grays are used with other pastel tints, a subtle neutralizing effect is obtained, and you can create a greater sense of recession in your landscape studies. I keep gradated sets in all the grayed colors like green-gray, purple-gray, brown-gray, blue-gray, and so on. You can easily see what tonal command is possible by using these offbeat tints spread through values ranging from the deepest dark to the lightest light.

It's a good idea to try creating monochromatic pictures with a full range of one color. The possibilities of this method are enormous, especially if you play up the tones with a skillfully chosen tinted paper.

Your personal pastel assortment

You'll be anxious to build up your collection of pastels, and essential materials, as your interest in them quickens (*Figure 9*). But do resist compulsive buying, and be systematic in your purchases of pastels. Naturally you'll want your favorite colors, but buy these in a balanced range of tints. Assuming the scale of tone values in a color is from 1 to 7, 1 being the lightest, then buy the color in 1-3-5-7, or 1-4-7, or 2-6—that is, in a range of 4, 3, or 2 tones. However, while you can manage very nicely with some colors in a range of 4, 3, or 2 tones, there are other colors for which you'll need a fuller range, depending on certain landscape features. Sky painting, for example, obviously requires many more light and subtle tints than it does darker ones.

Actually it's best to work with a limited palette of well-chosen colors selected with a particular picture in mind. Sometimes you'll have to make special purchases, as I did when I was painting a group of begonias. To make sure I bought exactly the colors I needed, I took the flowers into the art supply store and matched the pastels to them.

Essentially, a landscape pastel selection is based upon muted variations of the spectrum colors: yellow, orange, red, violet, blue, green, and the lighter and darker shades of these colors. The bright, raw, or positive primaries have only limited use for such things as a brightly colored boat, a figure's clothing, billboard advertising, and the like. I encourage my pupils to think of these as man-made colors, as opposed to those of nature, which are more subtle.

Your method, or technique, of pastel painting will influence the extent of the pastels in your assortment. If you work very directly in method, you'll see the color and tone of a distant hill, and you'll select the pastel which exactly represents this and set it down in your picture with one stroke. If you work directly, you'll need a great number of pastels from which to select the particular one you want. On the other hand, you can get by with fewer pastels if your technique is one of blending, or working on a prepared ground of pastel underpainting, loosely applied so that it will influence the color that you put on top of it. This "indirect" method involves doing a certain amount of mixing similar to the traditional way of applying oils and watercolors. In any case, beware of overmixing in any medium; the result is invariably muddy and dull. I'm in favor of the direct, *alla prima* type of painting. It produces forceful work which has a vitality that seems to be in vogue today.

Making color reference charts

No good will come from choosing your pastels haphazardly. The serious pastelist must be systematic and methodical, and *must* make color reference charts for himself (*Figure 10*). I make mine on imperial-size (22" x 30") sheets of white drawing paper that have already been divided into ½" squares. I record every

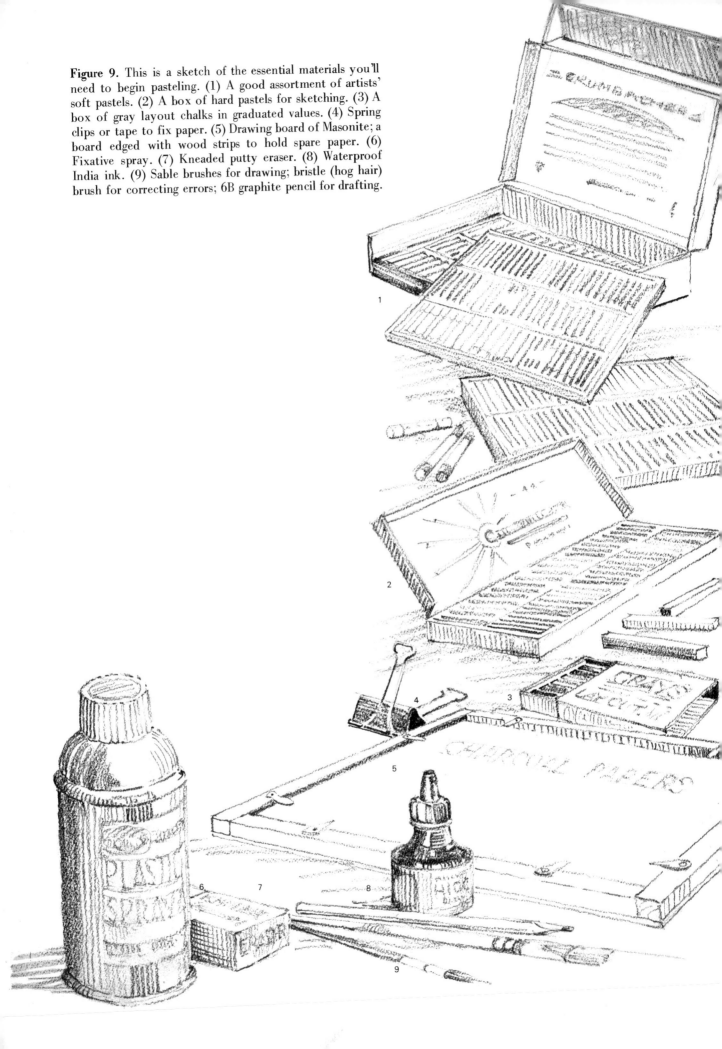

Figure 9. This is a sketch of the essential materials you'll need to begin pasteling. (1) A good assortment of artists' soft pastels. (2) A box of hard pastels for sketching. (3) A box of gray layout chalks in graduated values. (4) Spring clips or tape to fix paper. (5) Drawing board of Masonite; a board edged with wood strips to hold spare paper. (6) Fixative spray. (7) Kneaded putty eraser. (8) Waterproof India ink. (9) Sable brushes for drawing; bristle (hog hair) brush for correcting errors; 6B graphite pencil for drafting.

pastel I possess by filling in oblong areas composed of six squares, 1½″ x 1″ each, with all their colors and tones. I group these areas by various tints for the yellows, greens, blues, etc., naming them for color and shade.

Although this may seem a laborious task, it really pays off. For quite apart from increasing your knowledge of all the tints you've got, you can hang the chart on your studio wall and see them at a glance. Spray the chart with a little fixative to make it more lasting. (Grumbacher's Tuffilm Spray is a very good fixative; this, or a similar product, can be obtained from art supply stores and even from some of the larger stationery stores.) Once you've finished the chart, it will become a color-matching system that you can refer to when you're looking for a color that eludes you. It's also an excellent device for reordering pastels when you run out, for you'll be able to keep track of their names and tones when their flimsy wrappings become too damaged or too soiled to read.

When you're contemplating a picture to be pasteled with a limited number of tints, a color chart like this will make easy work of finding a suitable pastel. Otherwise, as you'll discover when you work with pastels a great deal, it's not always easy to find the stick you want without first testing it out on scrap paper.

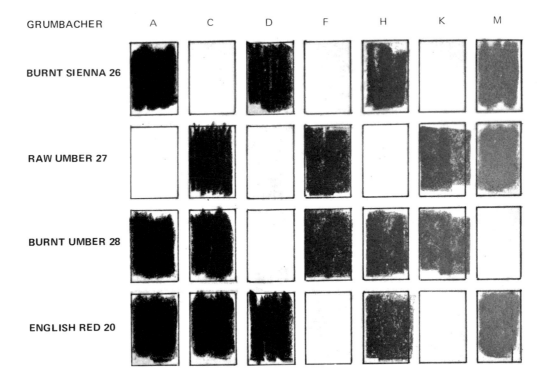

Figure 10. Here's an example of a studio pastel color chart. I made this one with a series of seven shades of gray to illustrate the method. Squares left blank are supposedly those tints not in my assortment. Note how seven spaces are made available for each color and how they're lettered at the head according to the tint of each. The line headed D shows the pure color, which gets lighter as it advances toward M. Those marked A and C are the shades with black added. (Don't forget to fix your chart with a squirt of fixative.)

Pastel care

The surfaces of pastel pieces soon become soiled through constant use and from rubbing against each other in the container. They need to be cleaned regularly by shaking up a handful at a time in a jar of ground rice. It's so much easier to find them when they're clean.

Pastel cabinets and store boxes

It pays to be orderly with your studio layout of pastels. I recommend that you consider the original boxed assortment as your store of pastels, because if you have any more than these, you'll need extra boxes or trays in which to keep them. In my own case, I do a great deal of painting and demonstrating with pastels, so my stocks are perhaps larger than normal. When a supply of new pastels arrives, I store them in a 20-drawer steel filing cabinet. Each drawer is partitioned, and lined with corrugated paper. My working trays are replenished from this store (*Figure 11*).

Of course, if you're a pastelist whose spare-time job is the presidency of a Texas oil company, you could get yourself a manufacturer's showcase. These are really splendid, and they're provided to retailers to hold their stocks of pastel sticks for selling individually. All the manufacturers have beautifully designed cabinets with drawers to take almost a full range. Mine, a generous gift from Rowney, is glass-topped and holds nearly 500 pastels. Grumbacher has a really fine, streamlined counter-top display cabinet handsomely finished in gray hammertoned steel, 15¼" x 29" and 8½" high. It holds 484 pastels, and using one of these would certainly help you to keep your stock orderly and readily accessible. With a bit of promotion chatter, you might be able to get one of these, full of pastels, for about $100.00. But remember, you want a single stick assortment, not a collection made up of six sticks of each color, like the one usually supplied to retailers by pastel manufacturers. (I'm afraid that Mr. Grumbacher will never forgive me for this!)

On the other hand, for a few cents you can store your pastels in empty cigar boxes, divided into compartments with strips of balsa wood, thumbtacks (pins), and balsa cement. They may not be as elegant as display cabinets, but I think you'll find that they serve the purpose just as well.

Working trays

I find that a large plastic hors d'oeuvre dish makes an ideal working tray (*Figure 12*), but any tray fixed up with half a dozen or so compartments will do. All the reds, blues, yellows, greens, etc., should have a separate place. This makes identification easier and the pastels get dirty less quickly when they rub against others of similar color.

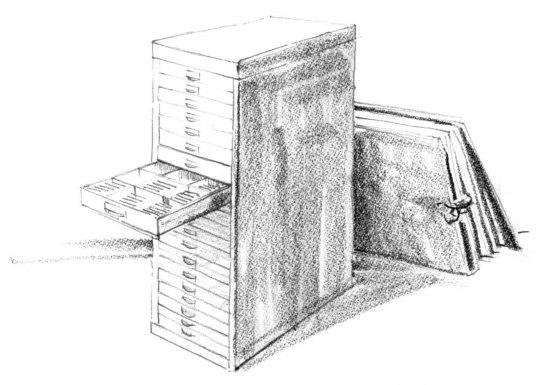

Figure 11. Pastel cabinets and portfolios for storing pastels and paper.

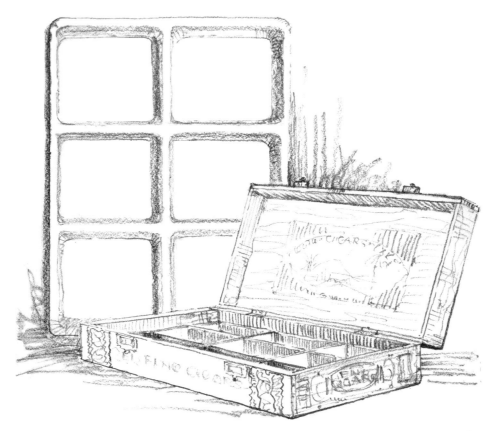

Figure 12. Here are some working trays: a plastic hors d'oeuvres tray and a converted cigar box.

Using pastels

When I take a new stick of pastel, I break off a 1″ piece from one end, return the remainder of the wrapped and labeled part to the store box, and drop the broken piece into its place in the working tray. The next time I want a similar piece, I take it from the other end of the stick so that the labeled wrapper is retained as long as possible. Finally, the wrapped center portion is used up; and if this exhausts my supply of this particular pastel, I make a note to remind myself to restock is. Thus I nearly always work with small pieces of pastel instead of the stick with its wrapper on. If you pastel with the whole stick, your work will become fussy and tight. As with oil and watercolor, you need plenty of color ready for your immediate use when making broad, expressive sweeps.

Making your own pastels

You're really an enthusiast if you consider making your own pastels. But it's quite easy, in fact. You can use all the tiny pieces that are too small to handle by crushing them into powder and then mixing them up indiscriminately. Dampen this mixture with water, and then compress it into empty watercolor pans, or press it into a thin tube. When it's dry, a pale gray color will fall out, ready for use. There's plenty of scope for experiment with this.

Sets of hard pastels

Although hard pastels have a limited use for pictorial purposes, they're very fine tools for the draftsman. They're particularly good for describing tone quickly, as well as for capturing the graphic quality of characterful line. Hard pastels are just the thing for the quick note on sketching trips (*Figure 13*), so they do have a real place in the pastelist's bag. I prefer to buy my hard pastels in boxed sets, in a series of either grays or browns. As I've already said, they are invaluable for all types of monochromatic work, illustration, and especially for layout drafts and preparatory stages in pastel picture making (*Figure 14*).

Hard pastels can be handled quite firmly and impart a very pleasant texture. They're available in a good range of colors in boxed assortments, although, like those of soft pastels (*Figure 15*), the assortments for landscape work are rather overloaded with the hectic colors. You'll find that a carefully chosen selection of the more subtle colors in the range of hard pastels will be extremely useful. There are many manufacturers of these chalk-based hard pastels. The Golden Palette series by Grumbacher sells for about $1.50 a dozen, and this is an excellent buy. Using any type of pastel presupposes that you'll draw and color with a small piece between your finger and thumb in a free, expressive manner. For those who prefer a longer pencil-like drawing tool, the pastel pencils made by the Swan Pencil Company, under the trade name of Othello, are delightful to use. In this case, the colored chalk is encased in wood, and you can sharpen it like a pencil.

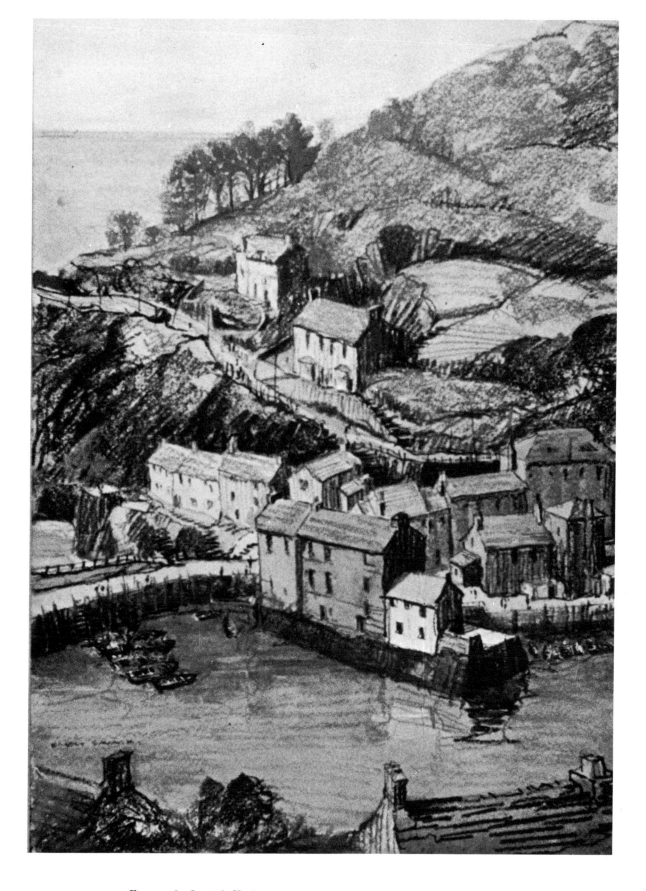

Figure 13. Cornish Harbor, 14″ x 20″. The fishing village of Polperro clings to the steep sides of a rocky inlet facing the Atlantic approaches. This is an unusual view of the inner harbor as seen from the cliff top. For this study, I used hard pastels on a watercolor wash groundwork.

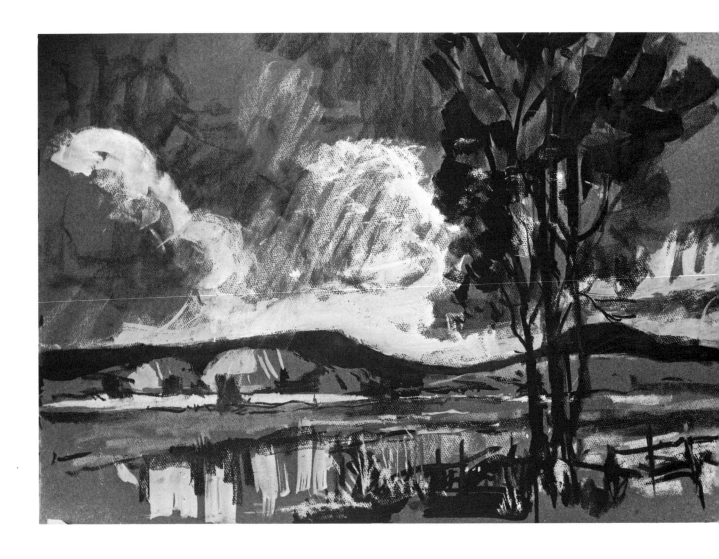

Figure 14. Amberley, Sussex, 22″ x 30″. This was one of my Art Society demonstrations. To encourage bold treatment, the initial draft for the picture was vigorously laid in with black India ink on an imperial-sized, gray Charko Board. I used an ordinary 1½″, flat housepainter's brush, much to the astonishment of the audience. The ink dried quickly and I then set to work with a similar brush to put a cream gouache above the black hills. I added more yellow to the gouache mixture for the streak of sunlight at the foot of the hills. For the light reflections in the river, I added a further touch of purple to neutralize the mixture to a warm gray. After this, I began to pastel the sky area. See Plate 21 in the color section for *Amberley, Sussex*, final stage.

There are 60 tints in the Othello range and you can also obtain matching sets of short sticks like the true hard pastel from the same manufacturer.

Oil and wax pastels

I hope you'll have noticed that I stress the use of chalk-based pastels; we don't want the problems of wax or oil crayons troubling the serene waters of our true pastel work.

At the risk of seeming offensive, I must say that I think oil pastels are a gimmick. Although extensively advertised, possibly because they're easier for retailers to handle, they have no real place in the studio of the pastelist. They're the poor relation of true oil painting, and should never have been called pastels at all. To do so is as ridiculous as calling a new art commodity an "oiled water-color."

In any case, oil and chalk are *not* compatible. Because of their robust quality, oil and wax crayons do have a place in the children's playroom, and in the school for educational purposes such as tinting maps and diagrams, illustrating projects, and conducting all kinds of graphic experiments. They have no place, however, in the field of fine art, so take my advice and ignore them. If you have any, please give them to the kids.

Figure 15. Soft pastels, like hard pastels, are available in boxed assortments from many excellent manufacturers including M. Grumbacher Inc. (shown here), Talens and Sons, Inc., George Rowney (Great Britain), and Lefranc (France). This Grumbacher assortment contains 114 shades of soft pastels, but the serious landscape pastelist would do well to start with a box of about 90.

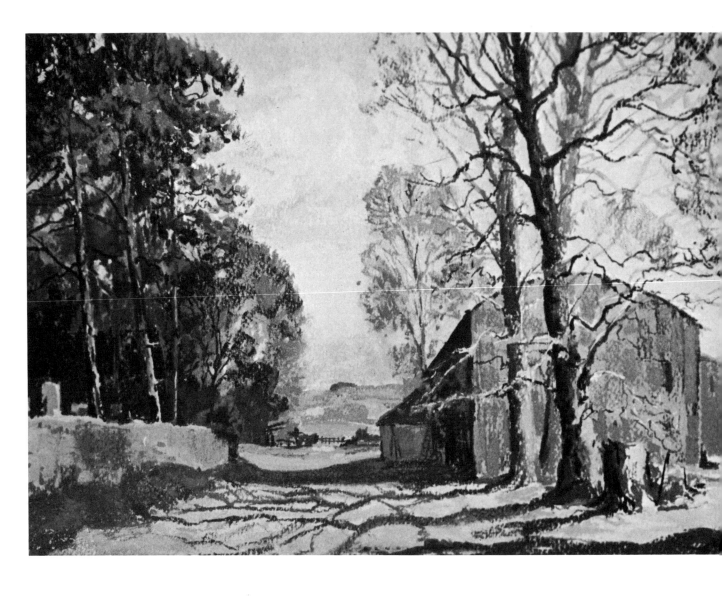

Figure 16. Spring Sunshine. This sketch was made on charcoal paper with a good toothy surface. The paper's texture helped me achieve the feeling of light shining through the middle tones and darks of the leaves on the trees. This is because the pastel was deposited *only* on the surface of the paper's grain. The white of the paper also breaks up the darks of the shadows cast by the tree in the foreground and gives these shadows a fine translucent quality.

3. Pastel Supports

I'm as keen about pastel papers as I am about pastels themselves. I constantly replenish my stock wherever I happen to be, and I'm always looking for something different. I have vivid memories of once spending an hour or so in a *cartolaio* in Venice. This most luxurious art store, housed in what appeared to be a renovated Venetian palace, was only a stone's throw from St. Mark's Square and overlooked a canal spanned by a lovely stepped and grilled bridge. It had the most extensive stock of papers of all kinds that I'd ever seen. It wasn't until I left, with a huge roll of paper over my shoulder, that I wondered how I could possibly get home with it. In order to take back this supply of Italian Ingres made by Fabriano, clothing was sacrificed—not mine of course; my wife's. All in the cause of Art, I explained!

Pastel surfaces

A surface (also called a support) must have something of a grain or texture to accept pastel well (*Figure 16*). This means that very smooth surfaces are out. Charcoal papers that have good toothy, textured surfaces are very popular. They come in many weights, tints, and tones, and some are already mounted on thick white cardboard (card). Most pastelists use this Ingres-type paper, which originated in Europe but is now manufactured in America, France, Italy, Sweden, and Germany.

Different types of charcoal paper are generally used for pastel work, but there are also many other types (*Figure 17*). These include: grained paper or cold-pressed watercolor paper mounted on white cardboard; stretched canvas or canvas-covered boards, both with varying textures; synthetic flock papers with velvetlike surfaces; large sheets of sandpaper; and plywood and veneered board. And don't hesitate to experiment by trying to make your own texturized supports. I hope you'll welcome chances to experiment, even on surfaces such as wood, for example.

A

B

C

D

E

Figure 17. Here are some examples of paper texture and how it effects your pastel strokes. (A) A smooth surface where the pastel shows little effect. (B) Strathmore Artist drawing paper, showing improvement of strokes because of the slight texture. (C) A cold-pressed watercolor paper (Fabriano), with more tooth, begins to separate the pastel particles. (D) Separation is now more pronounced on this rough watercolor paper. (E) This is the effect of pastel used on a typical laid charcoal paper.

Trying out new surfaces

I was recently impressed by a very fine pastel portrait of Nureyev, the Russian ballet dancer, which was on exhibit at a leading London gallery. It was pasteled on a sheet of plywood that had obviously been extracted from a corner cupboard. The art work was loose and dramatic, and much of the wood surface had been left showing through. The artist had also made use of the natural whorls of the wood grain, and the whole was well presented in an attractive glazed frame. As this unusual support proves, it certainly pays to maintain a constant inquiry into surfaces that might be suitable for pastel work. Try out those that you think might be interesting, even though you've never seen them used before. Who knows what exciting results you may get from your venture into the unknown!

The influence of the support is much more noticeable and certainly more important in pastel work than in any other medium. The varying surface texture of the paper will be evident in the finished painting, as will the degree of the paper's hardness or softness, its color or tone, and its stiffness or resiliency. When all these factors can, in turn, be associated with some five different methods of laying on the pastel, you can easily see the possibilities for a wide variety of techniques. All serious pastelists should investigate and experiment in order to take advantage of the different effects that can be obtained.

The five ways of handling pastels are as follows: (1) using the pastel on its side and creating areas of color; (2) drawing with the end of the pastel and making a series of lines as in hatching (fine lines drawn close together to produce a shading effect); (3) pressing the point of the pastel into the support to render spots of separate color in the manner of the Impressionists; (4) rubbing the pastel onto the surface of the paper with finger or pad; and (5) using a combination of any of these methods in the same picture.

Color and tone for pastel surfaces

The surface texture of your support influences the effect that you can achieve by manipulating pastel in the various ways I've outlined above. But the color and tone value of the surface is of even greater importance than its texture. Most pastelists leave varying proportions of the original color and tone of the paper untouched with pastel so that it will show through in the finished work.

This opens up many avenues for exploration, for if you carefully study the surface color and tone, you'll soon see how you can put them to work as an integral part of your picture (*Figure 18*). If you tend to overwork and cover the whole paper surface with pastel, the paper's original color or tone is of no use whatsoever. And there's no doubt in my mind that by doing so you miss a marvelous opportunity to obtain a fresh atmospheric effect. This is particularly true when you're working on a landscape. If, for example, the original color of your paper is blue-gray, areas of this color can be exploited for, say, the silhouette

A

B

C

Figure 18. These examples show how paper tone effects pastel. Always remember that the tone of the paper has nothing to do with its color. The tone, or value, relates to its degree of lightness or darkness. In experiments A, B, C, above, the darkest toned paper, i.e., black, was chosen for use with white pastel. With this combination, the effects will be more evident, as will the subtle changes of pressure upon the pastel, that give variations in the tonal result. In (A) white pastel was used on a black ink groundwork overpainted on very rough paper. (B) shows white pastel strokes on a smooth black paper. In (C) white pastel was applied to black charcoal paper.

of distant mountains. Because the color is unsullied by chalk particles, the mountains will have an extra luminosity that you could not otherwise obtain.

Surface colors

When you're selecting papers for a pastel study, remember that their color and tone should be chosen for the particular subject matter you're going to be working on in your picture. Try to select a paper of a tint that will help your picture, especially in the areas you're planning to leave untouched. There are paper colors that will obviously help you achieve certain effects. Warm brown papers are suitable for studies in the fall; cool grays and pale blues provide the right tones for winter scenes, as do neutral greens for woodlands and trees. If you're a beginner, avoid vividly colored papers like yellow, red, violet, orange, etc. These are very difficult to use in landscape work if you haven't experimented a great deal with them. And don't use black paper unless you have some very special effect in mind.

Surface tone

By far the easiest tone of paper to work on with pastel is a medium one, that is, a tone halfway between black and white. You'll run into problems if you use very light or very dark papers, because it's difficult to fill the grain of a light paper with dark pastel, or the grain of a dark paper with light pastel; to completely cover either, you have to press the pastel very hard into the surface.

You should also keep in mind that color tones have a very definite effect on one another. A blue, for example, will seem a great deal different next to a green than it will next to a yellow; so a constant comparison of the relationship of one tone value to another is very important. When you're pastel painting directly from nature, you can frequently decide before you begin work which part of your picture will be represented by the tint of the paper. This paper tint then becomes your tone guide to help you judge which parts of your subject seem lighter in comparison to it, and which seem darker (see Plate 1 in the color section). For this reason, if you use paper of an extreme tone—whether very light or very dark—it becomes difficult, when you're using it for comparison, to make a correct judgment about the true tone value of something in your picture.

Colorfast papers

If you want to employ the technique of allowing paper to show through the pastel in your important work, you must be sure that the color of the paper is unlikely to fade. If it should fade, the whole effect of your original painting may be altered. It's very easy to test the colorfastness of paper in the following way: just tape a swatch of various colors to your window, and expose it to the direct

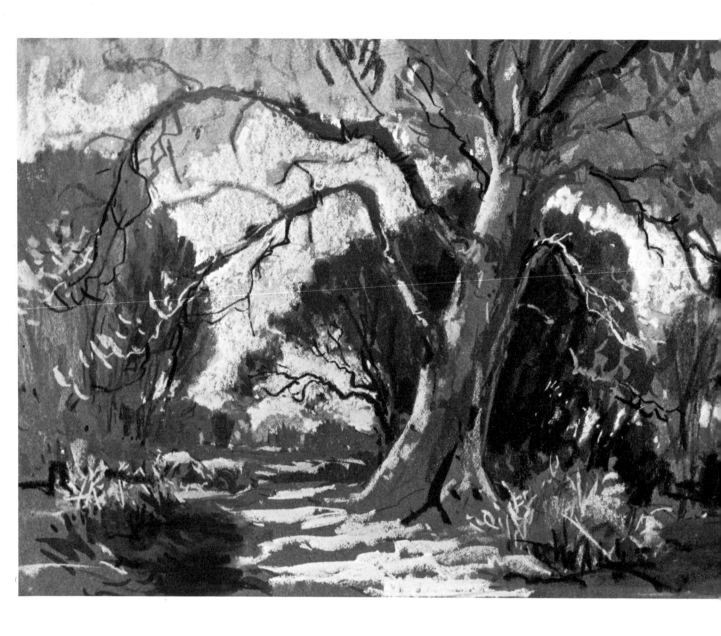

Figure 19. The Old Oak, 19″ x 25″, Private collection. This was another on-the-spot study. For it, I used a dark brown charcoal paper that had been previously mounted down on thick white cardboard. In the broad pastel stroking, much of the nut-colored paper was allowed to show through. This is a typically direct work of mine in which I aimed at securing good contrast of light and dark. I used the paper color as the mid-tone and to kill the dark of the paper, I rubbed my very lightest gray pastel into the sky areas that showed through. You can see this rubbed tone at the top. Later, I again worked over some parts of the sky with direct pastel strokes. This study was purposely left unfinished, so that my technique can more readily be seen.

rays of the sun for several months. Don't forget to date your experiment at the start. You'll be surprised at how quickly some colors fade. These are the ones to avoid.

Generally, charcoal Ingres papers of the best quality have good staying power as far as tone and tint are concerned; but even these vary. The purple and greenish tints are the most unreliable. You'll find that the cheap colored drawing papers, like those used in schools, fade very quickly indeed.

White papers

For my pastel landscapes I often use watercolor paper—the white, cold-pressed kind—which comes in various textures. But to form an underpainting for my subsequent pasteling, I always lay in an over-all tint of whatever tonal value I need on white papers, using watercolors or gouache (opaque watercolor), or even rubbing in pastel. I'll explain these special underpainting techniques later.

Some paper manufacturers

I'm going to mention only a few of the world's leading paper manufacturers, so many will be omitted which are equally reliable. Therefore, it's important that you shop around to familiarize yourself with as many papers as possible.

Strathmore charcoal paper, 100% rag, is one of the best papers available in the United States. It comes in one weight—64 lbs.—in 19″ x 25″ sheets, in white and ten different colors. You'll find it's stocked in the stores in the flat-deckled-edge sheets I've just described, as well as in pads of three convenient sizes, 9″ x 12″, 12″ x 18″, and 18″ x 24″. The sheets in the pads are all white, all one color, or a selection of assorted colors. I used Strathmore charcoal papers for many of the original illustrations for this book (*Figures 19 and 20*). They're very sympathetic to my style of direct pasteling.

The Crescent Cardboard Company mounts these Strathmore charcoal papers on good quality boards and markets them under the brand name of Charko Board. These prepared boards are fine to use, although you must remember that some of the toothy texture of the charcoal paper will be lost in the process of mounting. There are two advantages in using these boards. First, you save time because you don't have to do this job for yourself. Second, if you're nervous about the possibility of spoiling your pastel when it comes to pasting it down on cardboard prior to framing it, you avoid this problem. Unless you're using very heavy quality papers in small sizes, say, no larger than 12″ x 15″, which can be framed without mounting, most charcoal papers need to be pasted to a support. Pastelists often prefer to use unmounted papers to get the best possible texture for their pastel technique. They then paste down their finished work on white mounting boards. These processes are fully discussed in the section dealing with mounting, matting, and framing.

Incidentally, the Crescent Cardboard Company markets a wonderful range of colored drawing papers and matching boards which are suitable for pastel. The same company also produces watercolor and illustration boards in a variety of interesting textures.

By far the most important of the European pastel papers are the French Canson Ingres and the heavier weight Canson Mi-Teintes; the Swedish Ingres called Tumba; and the Ingres and tinted drawing papers made by Fabriano, Italy. All these manufacturers produce papers of the best quality in a very wide range of tint and tone. Most of the Ingres-type papers are sold in a royal size, approximately 19″ x 25″; the heavier-weight papers come in imperial size, 22″ x 30″.

Ingres paper was named after the French portrait painter Jean Ingres (1780-1867). It's a handmade paper with an irregular, unmechanical texture which has been made by Canson-Montgolfier since 1567. It's often said that the Montgolfier brothers started man's flight to the moon: they launched the first hot-air balloon made from their paper in 1782. This event is still commemorated at the mill; each year they make a large replica of the original balloon for an aerial display at the local summer festival.

Canson Ingres is made from an all-rag pulp, and it's watermarked with evenly spaced parallel lines. It's extremely durable, and the thirty or so colors in which it's made will not fade. This paper has the same substance and comes in the same

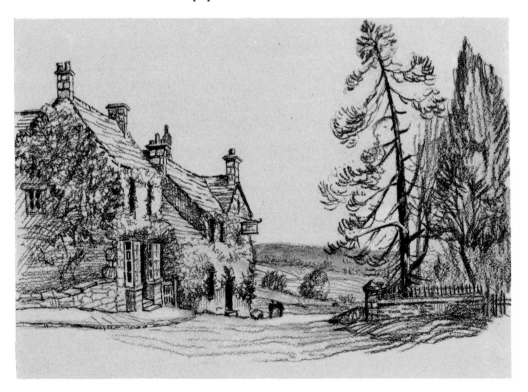

Figure 20. Cotswold Inn. I started this sketch by indicating the outlines of the building, hills, and trees in brown ink. I then used a black Conté crayon and a direct pasteling technique to boldly indicate the shadow areas. My darkest darks were reserved for the deep shadows within the doorways and windows of the inn, and for the two figures on the road.

range of sizes as the charcoal papers so it's a good alternative.

Canson Mi-Teintes are colored, heavier-weight papers which have been made for nearly 200 years. These are great favorites of mine, because I find them very responsive to pastel work. The heavier weight of the paper eliminates the need to mount smaller paintings on cardboard before framing. Watercolor and gouache washes may be successfully applied to these papers without the puckering that you experience with the thinner Ingres charcoal paper. Remember, if you use wet paint on charcoal paper it's best to mount it on cardboard.

Either side of Canson Mi-Teintes paper can be used for pastel, for each has a distinctive grain. You'll find it a nice change from the texture of a laid paper.

Collecting paper samples

It takes no time at all to gain extensive knowledge of all the wonderful papers that are available for you to use. Write to each manufacturer or their agents, asking for a sample swatch of the full range of all their charcoal papers and boards. You'll find their addresses in the Appendix of this book. You'll then have a comprehensive collection of paper samples that you can examine for color and tone, and for texture and grain. You can then learn color names and reference numbers and ask your local retailer to order the exact paper you want.

Protective papers

It's wise to set yourself up with a supply of paper to protect your pastel work. Almost any smooth, thin paper will do. You'll find it most convenient to have protective paper the same size as your picture, taped or stapled to one corner. I buy large rolls of inexpensive household wax paper for this purpose; the wax paper can also be used for tracing. But even a piece of newspaper will do, if you can tape it down so that it doesn't rub against the picture. Sheets of clear plastic sheeting are ideal for protecting a pastel that's rolled in a tube for mailing.

Storing paper

It's best to store paper flat in a large drawer or portfolio, or on a shelf. If you can afford it and have the available space, a blueprint or plan chest is ideal. Because this type of chest has several drawers, you can store both the paper and your finished work in it. In my studio I have a double, elephant-size, four-drawer chest and an imperial-size three-drawer chest. The tops of these chests make admirable working surfaces for painting, cutting mats and mounting boards, mounting pictures, framing, and so on.

There's no real danger in keeping your store of paper neatly rolled up in a cupboard or lying flat under the bed, but these places are more difficult to get at than a portfolio or a drawer. But remember, keep the paper dry.

Figure 21. (Left) Bristle (hog hair) brushes are good for sweeping off any pastel areas needing correction. Blow as you sweep. A series of finely pointed sable brushes are a must for ink line drawing.

Figure 22. (Below) The Sussex easel is the ultimate in all-purpose, portable easels.

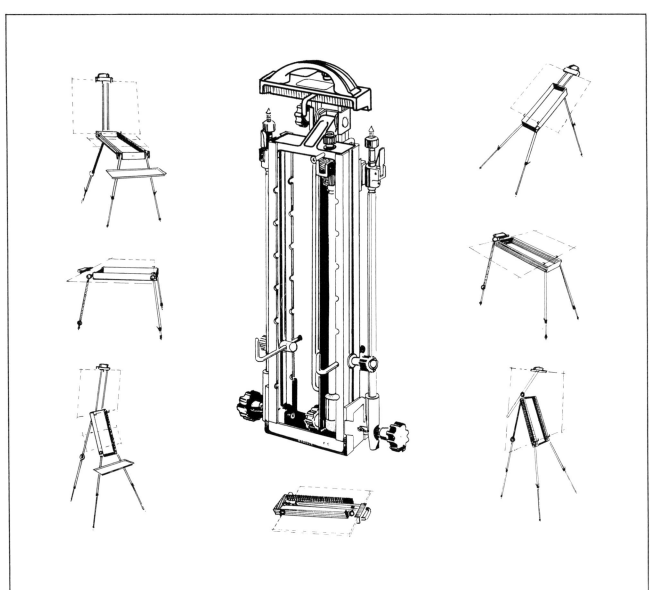

4. Equipment

General painting equipment, such as easels and studio items used for oil or watercolor painting, can be used for pastel work. The extent of your equipment will depend on the degree of serious work you intend to do and the space and resources at your disposal.

The ideal setup would be a room that you can use exclusively for your own well-equipped studio; then if you have to interrupt your work, things will be just as you left them when you return to it. On the other hand, if you use a family or communal room, it means that you'll always be having to take things out when you set to work, and then having to put them away again when you're through.

As I've already mentioned, excellent work can be done with the simplest of equipment and materials. However, some people find that they need the spur that comes from working in a well-equipped studio. Serious pastelists who want to develop their interest in a big way will certainly want a studio to themselves. They should find the description of my own studio layout helpful, so I'll go into it later, describing as well all the gear I use for outdoor painting excursions.

As a landscape painter, your equipment requirements are twofold: although you'll want a good home-based studio, your field kit is of paramount importance. You're only going to become an accomplished landscape painter by doing a great deal of study on location, directly from nature. The constant observation of the natural landscape around you and the continual collection of sketch material based on these observations, will build up a reservoir of knowledge in your mind that will enable you to accomplish more effective and serious work in the studio. I'm afraid firsthand experience is a necessity that you can't evade if you want your work to have the real originality and complete freshness of outlook that landscape painting demands.

General items

You may already have most of the auxiliary items of equipment and materials you'll need for working with pastels, such as pencils, charcoal, waterproof India

ink, and colored inks. I use a variety of felt markers, especially the Japanese fiber-tipped Pentel, for sketch drafting and compositional roughs. But some of these inks are not very lasting, so avoid using them for permanent work.

It's a good idea to collect sketch notes and illustrations in spiral-bound sketchbooks, using either a brown or black Pentel, 6B graphite pencil, or a Conté crayon. For laying in the composition of a serious picture in which the ink shows through in the finished effect, you should use *really* permanent black India ink or brown waterproof ink. A variety of fine-pointed round sable brushes (Nos. 4, 6, 8, and 10) are suitable for working with these inks.

Your brush drawing should be made directly on tinted charcoal paper. However, if you lack the confidence to do this, you can begin with a pencil or charcoal draft and then go over it with brush and ink. Skill in brush drawing is something to cultivate because of the quality and vitality of expression you can achieve by this means. I think that the felt-tipped markers are presently overused; they can never compete with the expressiveness of brushpoint lines. By using a brush you can start a line as thin as a hair, and finish it as thick as a stout rope.

To sum up, you must have some sable drawing brushes and one or two old bristle (hog hair) brushes for cleaning off pastel work (*Figure 21*). Any other brushes that you normally use for watercolor and gouache should be included if you decide to enter the exciting realms of mixed media.

The portable easel

The most important single item of equipment that you'll need is the easel. For outdoor pastel work, get the best quality portable easel you can buy, one that will serve for both outdoor and studio work. My own is a prized possession. It will carry any size drawing board up to 30″ x 40″, and allows me to place the board firmly in any position I may need. It lies absolutely horizontal or at any angle of inclination up to the vertical; I can even lean it with the top towards me. The easel grips the board so securely that the board easily withstands the firm pressures so often needed when pasteling. And the wide range of positions that the board can assume makes this easel suitable for work in every medium. In fact, I've often used it as a table and served tea on it! However, when folded up, the easel is no more than 24″ long and weighs less than 5 lbs. The artist can either sit or stand when using a board of this kind, and it's very simple to adjust to accommodate his position. None of its generous-sized knobs can come off and get lost, and it comes with an easily detachable tray into which small items of sketching materials can be placed. It even has three rubber feet that retract to expose stainless steel spikes. Hence the easel can be safely used on polished floors (with the rubber feet alone), or—with the spikes exposed—on uneven, rough surfaces.

I guess by now it's pretty obvious why I'm so enthusiastic about this truly all-purpose easel (*Figure 22*). I had something to do with its design. It's now being

made by the Sussex Forge and Engineering Company, Fittleworth, England, and I'll describe how its existence came about.

I had just about given up all hope of ever finding an easel that suited all my special needs when I met an aeronautical engineer who was interested in making a prototype easel to my demanding specifications. This engineer already had something of a reputation because he had been responsible for the design and manufacture of some of the safety gadgets on the French and British supersonic Concorde airplanes. The easel he designed for me has the appearance of a precision instrument, is superbly made, and looks resplendent in polished and anodized Duralumin. It can be carried by its handle or will pack in an ordinary suitcase. But it's only just coming into production, so I'll reserve further details about it for the Appendix.

You'll find that most sketching easels seem to be more suitable for oil painters and for vertical painting. Most of those manufactured for watercolor and pastel work seem flimsy. So take my advice: when you buy your easel, look for the qualities I've described. If necessary, you can have the salesman erect the easel you select in the shop, so that you can test its stability under the pressures you're likely to apply when pasteling. Satisfy yourself that the easel will carry your board at any angle. Although it's customary to have the board at a steep angle for pastel work so that the chalk dust falls away, it's equally important to have a board that can be adjusted to a flat angle for laying in the underpainting washes of watercolor and gouache. In any case, it's a decided advantage if your easel can be used for all media, and for both indoor and outdoor work.

Incidentally, I run many summer schools for amateur artists, and there's always somebody in attendance who has portable-easel trouble! This is either because they have an unsuitable easel, or because they expect it to assume a position for which it was never designed. Many students simply never found out how their easel works and they can't put up the wretched thing. Others have lost vital parts of it!

You must get so well accustomed to setting up and dismantling your portable easel that you can do it with effortless ease. When I'm putting up mine, my thoughts are upon the picture I'm going to paint and the effect I want to create, and my gaze is upon that part of the landscape I've selected for my picture. If you have to engage in a struggle with your easel before you begin to work, it cannot do anything but put you off. Learn to get the most out of your easel.

The heavy, rack easel is fine to have for large studio work and display purposes. It looks important, too. Tables that tilt are excellent for studio pastel work, and they can be obtained in a variety of designs from firms who specialize in drafting equipment (*Figure 23*). A glance through the advertisements in *American Artist*, especially the Artist's Guide Issue, should set you reaching for the phone. But be careful not to get carried away by beautiful displays. Remember, you should try out whatever you select *before* you buy.

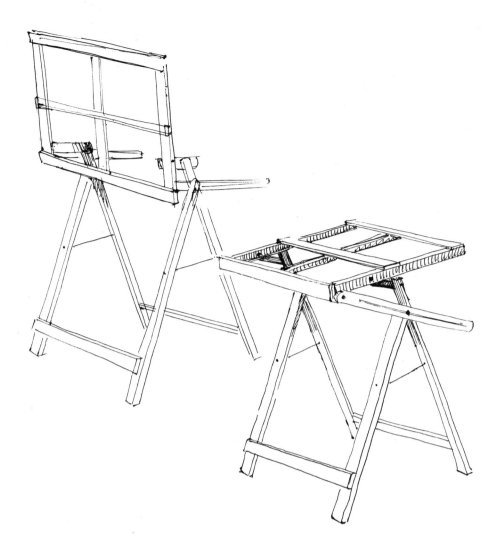

Figure 23. An example of the drafting-type table which can be tilted. This is the Hunter easel, marketed by Winsor & Newton, Ltd., England.

Drawing boards

You'll need several drawing boards in assorted sizes. They can be of Masonite or plywood, though you can use the traditional braced drawing boards for studio work. For field work, I use a portable drawing board that also serves as a carrying case for my papers and for safely bringing home unfinished pastel sketches (see *Figure 11*). I made mine by gluing ½" bands of wood around the four edges of a 21" x 27" sheet of plywood. This makes a sort of tray for the normal-size 19" x 25", charcoal papers. I then put a thin sheet of cardboard on top and hold it in position with a few metal clamps.

I also carry a thin plywood sheet, 12½" x 19", which I use for working on half sheets. I use clips or drafting tape to hold the paper on the board.

Whichever board you use, remember to put a sheet or two of paper or thin cardboard under the surface of the paper on which you are going to pastel. This not only gives you a resilient pad on which to work, but keeps you from picking up any of the irregularities in the surface of the plywood.

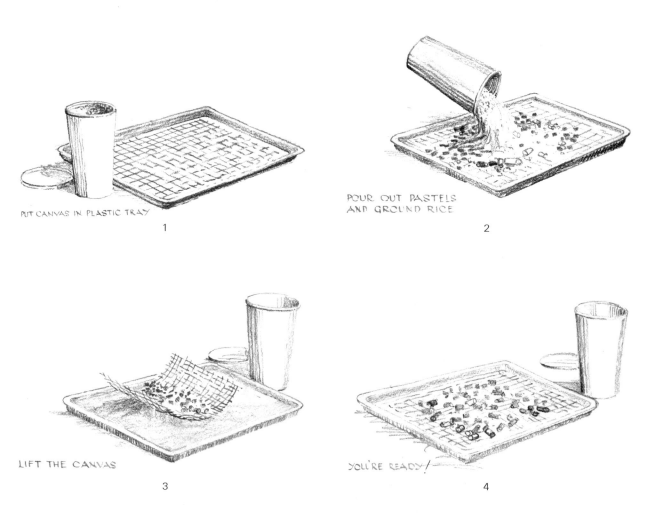

PUT CANVAS IN PLASTIC TRAY

1

POUR OUT PASTELS AND GROUND RICE

2

LIFT THE CANVAS

3

YOU'RE READY!

4

Figure 24. When you're working outside, and have got yourself settled and ready to start work, you'll need your pastels! The instructions above will make the procedure easy.

Field boxes for pastels

You probably won't have to go any farther than a nearby hardware store to find just the kind of lightweight plastic boxes and containers you need for carrying your pastels on sketching trips.

For my sketching set of pastels, I always use a snap-lid plastic container. (These pastels that I use on field trips are kept separate from my studio working set, which is in a partitioned tray at home.) I pour the broken pieces of pastel into the container and then top them with ground rice (available in specialty food stores). The rice protects the pastels from breaking, and keeps them from rubbing together and thus getting soiled (*Figure 24*). What's more, since the rice moves when I move, it actually cleans the pastels by gentle abrasion as I walk along! I change the rice when it begins to look very gray, for then it ceases to be effective.

I also keep a reserve stock of whole or partial sticks of pastel in lightweight plastic boxes that I line with absorbent cotton—again, to keep the fragile sticks from breaking.

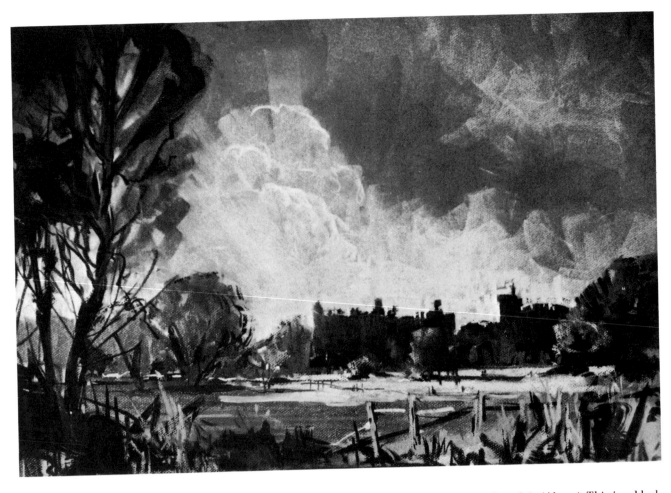

Figure 25. Storm Clouds, Arundel. (Above) This is a black and white copy of Plate 23 in the color section included to give you some how-to notes. Arundel Castle is the ancestral home of the Duke of Norfolk and, as such, it's one of the best preserved castles in Britain. It overlooks a flat river valley of considerable natural beauty. I took some care to get a likeness in the silhouette of the turreted buildings, which I pasteled against the sky with a deep blue-gray. I did the foreground trees and the post and the railed fence and weeds edging the brook in warmer darks to contrast with the coolness of those in the distant castle. My broad, direct approach was deliberate, for too timid a treatment could have resulted in too pretty a picture. I used no more than fifteen pastels for the entire work.

Figure 26. (Left) These old buildings in Italy were sketched with a fiber-tipped Japanese Pentel. I always use black or brown Pentels because they give the sketch a harmonious tonal quality.

In addition, I carry a 9″ x 12″ white plastic tray lined with a snug-fitting piece of coarse rug canvas. When I'm all set to start work on a picture, I empty the pastels from the rice-filled container onto the canvas. Then I lift the canvas and shake it a little so that all the gleamingly clean bits of pastel are separated from the ground rice. When I've finished sketching, I pour the pastel pieces and the ground rice in the tray back into the snap-lid container. This method doesn't suit those artists who like to have all their pastels separated by color. You'll therefore have to see which method is best for you when you start working outdoors. Figures 25 and 26 are examples of two of the many different types of sketches you can make outdoors. As you can see, even when you're only using Pentel, you can establish the composition and indicate the dark values.

Extra equipment for field work

You're going to need a sketching bag that will hold most of your equipment. I have two that I keep permanently packed, ready for use. For a quick trip I use a briefcase (½ imperial bag) 12″ x 16″, packed with a drawing board of this size and essential bits and pieces of equipment. The other briefcase is 16″ x 23″. I carry my papers in strong portfolios which fit inside these cases. In addition, I keep the 21″ x 27″ portable drawing board available so I can take it in the car in case I should want to use a full sheet.

When you're packing your drawing papers, remember to include sheets of protective paper than can be interleaved with your pastel work to prevent undue smudging. As I mentioned previously, I prefer simple household wax paper, but tissue or newspaper will do.

I always take a lightweight sketching stool, for it's much easier to work sitting down. I spread all my pastels and other tools within easy reach on a plastic sheet laid out on the ground. You'll find it important to have a sheet of paper or plastic under your easel when working outdoors; newspaper will do when you can't find anything else. The sheet helps you find little pieces of pastel that slip out of your fingers while you're working. It's disastrous to lose the last piece of that special pastel color among pebbles or in the grass, especially because you'll probably be working fast when you're trying to capture fleeting effects of nature (*Figures 27A and 27B*).

A dust sheet, which serves the same purpose, is extremely useful when you're working in the studio. I call mine a "harmony sheet," because it means that there are less discordant notes when my wife, Marjorie, comes in to clean the studio!

Your outdoor kit (*Figure 28*) should also include a kneaded eraser for cleaning up your work errors. A box of facial tissues or paper towels, and a damp sponge in a plastic bag, are just the things for cleaning yourself up. You'll probably really *need* these things after a few hours hard work and you'll feel much more comfortable and relaxed if you know you have them with you.

Figure 27A. In this sketch and in Figure 27B, I used a 6B graphite pencil and Conté chalk. I make hundreds of these three-minute drawings; a glance at one of them often starts another picture off.

Figure 27B. Again, this is a quick visual notation for possible use in the future.

Figure 28. When sketching outdoors, I like to sit at the easel with all my gear within easy reach. I hold the plastic tray containing the pastels, and from time to time break off for a walk around, a survey of my work from a distance. Outdoor work needs concentration and taking a break for a smoke or a drink helps to keep you alert. Working for too long a spell can be fatal to your picture. So, take it easy; enjoy your pasteling.

My studio arrangement

I'm going to describe my studio arrangement to give you some ideas for arranging your own. My sketch (*Figure 29*) shows a corner of my studio; it's an indoor version of a bird's-eye view, which accounts for the eye level being near the ceiling. The studio is 18′ x 24′ and has wonderful skylights.

Jutting out from the main studio are three alcoves that face north, west, and south. In the sketch you can see the north alcove, which has a large, sloping window set into the roof that gives splendid natural light. Beneath the north light there's a built-in bench top running all around the 12′ alcove. There I keep all the paraphernalia I need for pastel painting. Above, two ceiling floodlights give as near a natural light as possible; I switch them on before dusk. You'll learn that lighting is very important. It's extremely difficult to recognize a correct tint of pastel in the yellow light of an ordinary electric light bulb.

I use my easel like a drafting table so that I can tilt it at any angle. When I stand to work on my pastel, I raise the board. In my sketch it's placed in its usual position so that I can use the light from the left. I sometimes set up my portable easel where it gets the rest of the north light, if two jobs are being done at the same time. And I often do two jobs at a time because I like to switch from one picture to another, until one commands my full interest. I find, too, that it's very important to have enough space to walk away from my work and view it from a distance.

All my equipment is so arranged that it's close at hand: loose bits of pastel, absorbent cotton, kneaded eraser, and a bristle (hog hair) brush are kept in the dish on the shelf to the right of the easel. Farther to the right there's a table on which I put extra pastels and my six-compartment hors d'oeuvre tray. (I often hold the tray when I'm working.) There's some corrugated paper on the table to hold special pieces of pastel that will be used again and again. You'll probably recognize the plastic sheet under the easel and stool; it's the "harmony sheet" I described earlier.

Under the bench there is a chest for paper storage, and the previously mentioned steel filing cabinet to hold stocks of pastels. I keep the gift showcase from George Rowney on the bench top.

Now a word about the sketch itself. I used a sheet of Crescent's Charko Board, No. 1002, mist gray. I decided to use the tint of the Charko Board for the medium tonal value, and to paint the highlights with gouache. The whole drawing was done with black India ink and a brush. Various values in gray pastels provided a tonal scale. The darkest were used for the shadows beneath the benches, and for the table group (bottom right), which I wanted to be in shade because it was farthest away from the light source and nearest to the observer.

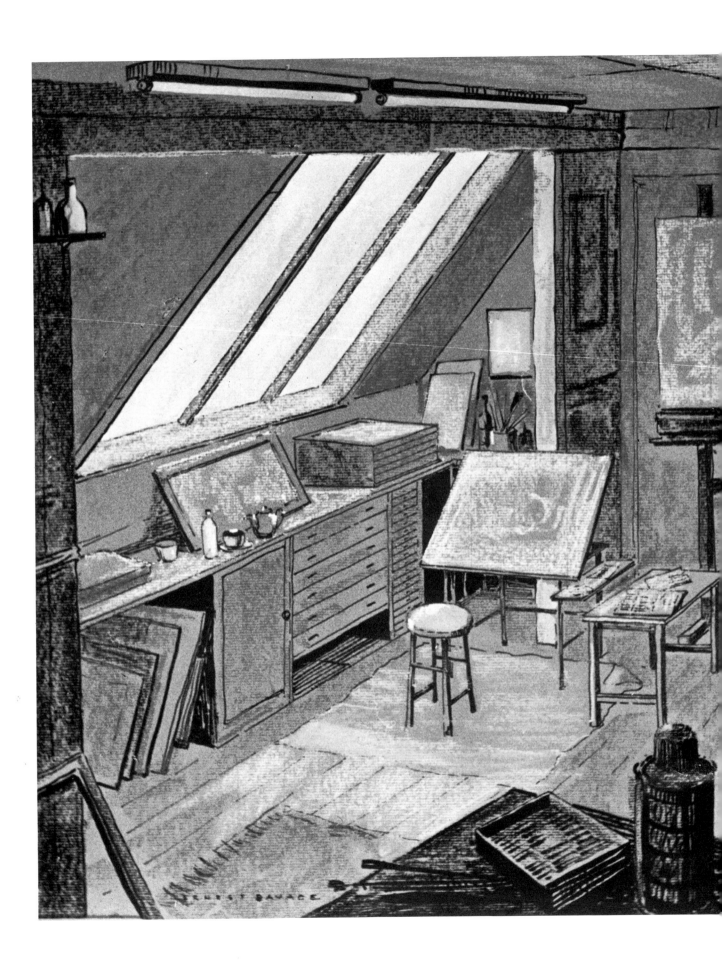

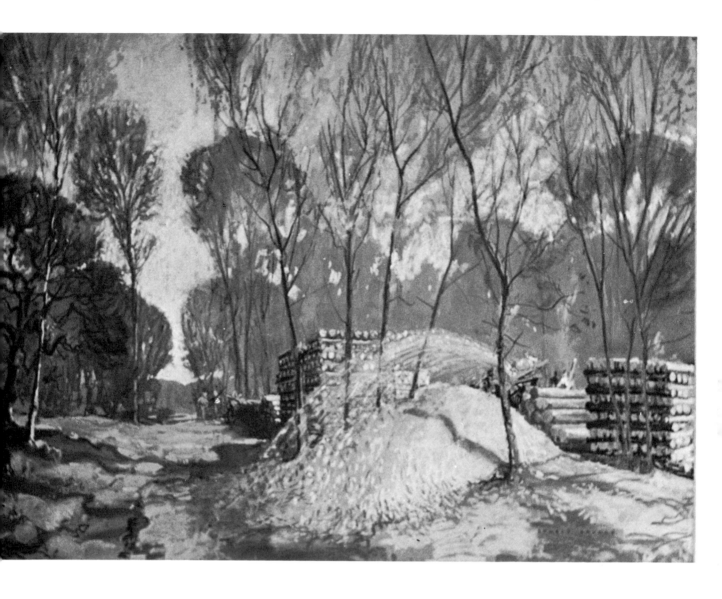

Figure 29. (Left) My studio setup.

Figure 30. Barking the Pit Props, (Above) 22″ x 30″, Private collection. I like making pictures of rural activities. When I discovered these lumbermen at work in our local woods, I thought the spewing stream of bark shavings was most attractive, and so made this the focal interest of my picture. I started the job with a brown chalk drawing on imperial-sized, gray charcoal paper. Next I pasteled loose strokes with pale blues and grays to indicate the tone of the sky seen through the trees. The whole tree area, together with the russet, bracken-covered ground, was next; this included the stacks of pit props. Finally, the spray of bark shavings falling into a heap and the men working were pasteled with firm, decisive strokes.

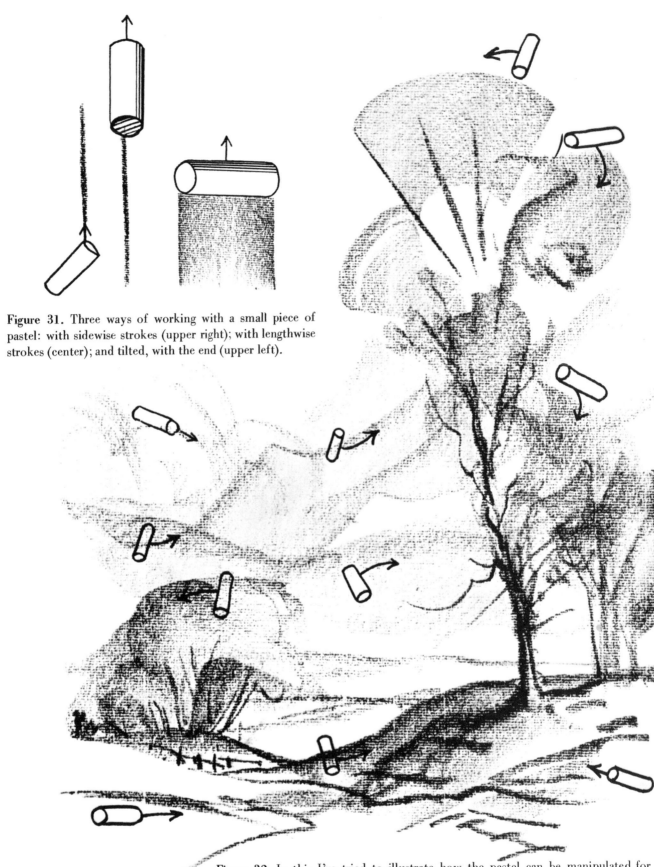

Figure 31. Three ways of working with a small piece of pastel: with sidewise strokes (upper right); with lengthwise strokes (center); and tilted, with the end (upper left).

Figure 32. In this I've tried to illustrate how the pastel can be manipulated for drawing and painting. I'm sorry if my pastel pieces look like UFOs. The arrow points in the direction that the stroke was made. This sketch really does demonstrate the freedom of expression that can be obtained with soft pastels.

5. Pastel Techniques

I think one of the hallmarks of good art is the technical competence that the artist reveals in his work. Your competence in handling pastels will rapidly increase if you keep experimenting. Be persistent in your search for the right paper and surface for the particular picture you want to do, and exploit its texture, tint, and tone; you'll soon develop an individual style (*Figure 30*). Always remember that your versatility in the pastel medium will only come with practice, and that you have to be prepared to make mistakes at first. If you're a beginner, I'm going to try to help you avoid some of the pitfalls by describing some essential techniques (see *Plate 2* in the color section).

Basic stroke techniques

If you're new to the medium, your first step should be lots of loosening-up exercises. After all, you couldn't expect to break a four-minute-mile record by getting out of your armchair and simply running it! It's the same way with art; you've got to do some training, and I hope you'll approach it with the idea of enjoying the coaching sessions.

Set up some sheets of tinted charcoal paper on a smooth drawing board. Prop the board up to an angle of 60° or 70°, so that the pastel dust falls easily away from your work. You're now ready to do some stroke drill; we'll go through the five ways, which are mentioned in Chapter 3, for applying pastel to any surface.

Area pasteling for beginners

Begin with a piece of pastel about ½″ to ¾″ long, broken off the end of the stick. Hold this between finger and thumb so that the side of the pastel makes contact with the paper, and practice broad, rectangular strokes. Follow this up with wide, curved strokes, allowing the hand to travel freely over the paper's surface.

Do these stroke exercises first with white and then with black pastels; watch the tones you produce with lighter and darker strokes.

Now let's fill a 9" square with a pastel tone. Keep the pastel on its side and fill in the square with rectangular strokes placed at random. Twist and turn your wrist so that the strokes are laid down in all directions, like the technique used in whitewashing a ceiling. Allow some of the strokes to overlap slightly; this creates a mottled-background effect. You'll find this mottled effect is excellent for painting skies. Alternatively, you can cover the area with broad horizontal or vertical bands of pastel. This technique is useful for depicting walls of houses, when the pastel can be lifted to leave the spaces for windows, etc.

Line strokes

This is mainly a drawing technique, in which the pastel piece or the whole stick is used on its end. If you want finer lines, look for the sharp, broken edges of the pastel. Wriggle the pastel about between your thumb and index finger to find the edge you want to draw with. Some artists sharpen the pastel end with a razor blade to get finer lines, but I never do because it wastes the pastel. If you examine a Degas pastel print, you'll discover that he used this method of hatched lines to fill certain areas in many of his ballet studies.

Try some simple line sketching with the pastel end to get the feel of it. As you work, think of the direction and structure of whatever it is you're representing. Allow your lines to follow the direction of the growth of, for example, the branches of a tree, or follow the structure of the boards on a wooden outbuilding. This is where your ability to draw will show through. If you're sketching in a building, it will help your drawing if the lines follow the true structure: use vertical lines for walls, and make your lines follow its actual inclination. Perspective will help you to create convincing buildings, so try to study a little basic perspective. It will help you achieve good spatial relationships in your pictures.

You can bring variety into your work in this method by changing the thicknesses of the lines (*Figure 31*). You'll see that this technique immediately increases the character of the line work, creating a more detailed description of the forms in your picture. *Figure 32* shows a sketch of trees and clouds. I used the pastel freely on its side and edge, applying it at varying pressures.

Combinations of color spots: pointillism

This method is similar to the first method of using the pastel on its side to cover areas with strokes placed at random. But this time, the strokes will be in the form of spots, made with the end of the stick (see *Plate 3* in the color section). To work this way, use two matching or contrasting colors and have your small strokes create a truly random effect. If you're too precise, the result will appear stilted and mannered.

The Impressionists, who were the first to use pointillism, were concerned with the problem of depicting vibrating light. So, since light could be scientifically broken down into the rainbow of spectrum colors when passed through a prism, they tried applying this approach to painting. By using a random pattern of complementary colors applied in small strokes or spots, they were able to convey an impression of sparkling light

When this method is applied to pastel painting, it's extremely valuable, because it enables you to gradually merge one color with another. In a sky, for instance, the more distant parts toward the horizon usually show subtle changes of tint. If you place spots of color side by side, they'll appear to merge together to create a pleasant atmospheric effect. You can see example of this technique in my little study of trees in the fall.

Rubbing and blending

Take a piece of pastel and gently scribble over a sheet of charcoal paper; now rub this passage of pastel marks into the paper with the tip of your finger (see *Plate 3* in the color section). Do you see the kind of misty effect you can produce? You can rub in the pastel with a pad of absorbent cotton, if you prefer. Try doing this with two or three different colors; they create an interesting blend.

Pastelists in the nineteenth century used chamois or wads of paper (stumps) for rubbing and blending, because they wanted to achieve as much realism as possible in their pictures. (Photography had yet to be invented.) Today, rubbing a pastel so that you produce a "perfect" blend is somewhat frowned upon. There's no doubt that the result of too much rubbing is an unpleasant, smooth-faced effect. However, an artist is free to do as he pleases. If you want to rub a pastel, why shouldn't you? The only requisite is that you understand what you're doing; so make as many experiments as you can with this technique. Do be sparing with the rubbed blending in your more important work, though. See if you can find another way of achieving the effect you want.

If you pass your finger gently over a hard-outlined edge of building or tree and smudge it slightly, you'll find it adds a more "atmospheric" softness. This technique is widely used in pastel portraits. But, again, don't do this too often, or the picture will have a labored and overworked appearance.

Combined methods

The rubbing method can be well used for setting up a tint or tone as background on which crisp strokes of pastel can be directly applied. In landscape studies, this and other methods are used to create an underpainting for the finished work.

To gain experience in the combining of pastel methods, try making numerous little imaginative landscape studies. In each study, mix the various methods of applying pastel. You'll soon discover the merits and problems of each technique.

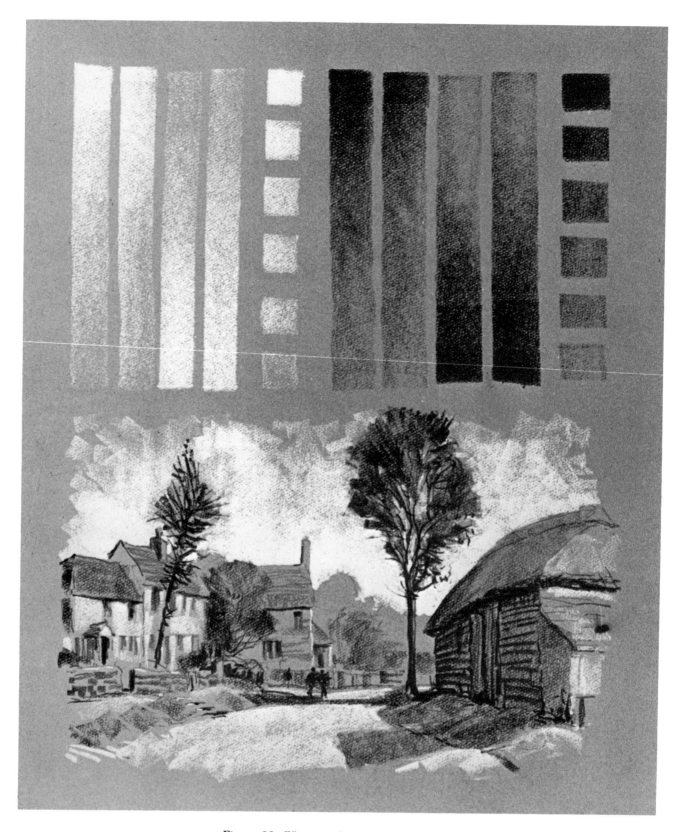

Figure 33. When you're trying to gradate your pastel tones, remember that the intensity of the tint and tonal value of a pastel depends on the pressure with which it's applied to the paper. This is a factor you must take pains to control. The practice drills illustrated show how light and dark pastels can be gradated in one stroke simply by carefully controlling the pressure on the pastel, from either strong to weak, or weak to strong. Another valuable exercise is to pastel a series of tone patches, each at successive pressures. Study the techniques used in the sketch below.

Gradations by pressure

You must have noticed, when you practiced your stroke techniques, that the color of the pastel marks varies in intensity depending on the pressure which you apply to your stroke. You need to develop control of this factor. You must learn to be subtle in your variations of pressure on the pastel so that you obtain the exact changes of tonal value you want. Obviously, if you press very hard with light pastels, you get the lightest tone; if you press very hard with dark pastels, you get the darkest tone. Pressing "very hard" means pressing almost to the breaking point of the pastel.

Examine the exercises illustrated in Figure 33. To make a gradated tone, use the side of the pastel. Start the stroke as hard as you can, then gradually reduce pressure until you finally lift the pastel from the paper. Your line should be graduated as evenly as possible. Now reverse the process. Begin the stroke very softly, so that the pastel gently kisses the paper, and then gradually increase the intensity of the gradation by increasing the pressure of the pastel.

Another useful exercise is to make a series of pastel strokes, one beneath the other, with the pressure applied to each stroke, getting weaker and weaker. This is fun to do, and you'll be able to easily see how successful you've been. This exercise can also be done in reverse by beginning the strokes very softly, and ending them at full pressure.

Being able to control variations in pressure is tremendously important. You'll discover that one pastel can serve to portray a variety of tone values. Knowledge and practice develop your ability to express form, texture, atmosphere, and spatial relationships.

Underneath the gradation practice drills (*Figure 33*) there's a pastel sketch of an old English village. Try doing a sketch like this on medium-tone gray charcoal paper. All you need are black and white pastels which you'll apply at varying pressures. You'll find it easier if you make your study at least three times the actual size of the illustration.

What are tonal values?

In every painting medium it's essential to understand what's meant by tonal values. This is because you have to assess them when choosing your subject and employ them when painting your picture. In fact, a good tonal representation is far more important than color itself.

Imagine that you're filming a black and white movie: everything you photograph will be in various degrees of darkness or lightness. Objects, people, skies, trees, etc., will be in shades of black and white; their actual *color* won't show. Indeed, it would be very simple to understand tone values if we didn't see any color at all. A tone value is the degree of lightness and darkness of a particular object you're painting. A picture has many tonal values

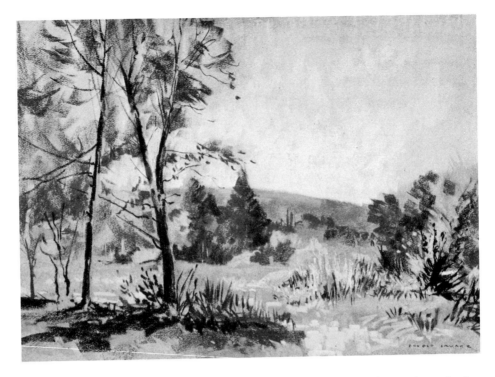

Figure 34. Trees on the Common, 20″ x 24″. Here's a monochromatic study that illustrates the use of a series of gray pastels in a direct method. Not only are the grays in gradated values from light to dark, but the strokes made with them vary in pressure. You can also see how the medium-gray toned paper influences the overall values of the study.

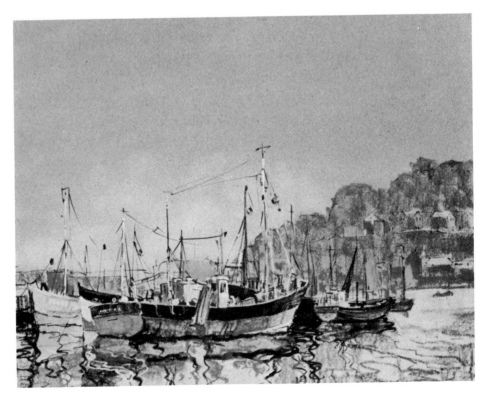

Figure 35. Trawlers in the Harbor, 20″ x 24″. The paper in this picture was chosen to suit the subject; predetermined areas of its dull gray-green tonal value show in the finished picture. The sky, for example, was left completely unpasteled. This was an on-the-spot painting, so I started with a carefully planned layout made with India ink and a brush and followed with a bold application of pastel.

If you think of white as the highest (lightest) tone value, and black as the lowest (darkest) tone value, the values in between white and black will be a series of grays, running from very light to very dark. A skilled painter is able to see at what point in the scale between the lightest and darkest values a particular part of the landscape falls. You have to learn this skill to get tones in your own pictures. You'll find it easier to make this assessment if you half close your eyes and peer through your lashes. Contrasts of light and dark are more easily observed this way, because your lashes act as a kind of filter, like a pair of sunglasses. When I'm on location and settled in front of my subject, I spend some time asking myself questions about the relative degrees of light and dark in the different areas of the landscape in front of me.

The first questions I ask myself are these: Where is the darkest dark. Where is the lightest light? When I've identified these, I think in terms of the intermediary tones. For example, is the roof of that building lighter or darker than the trunk of the tree? Is the sunny area on the road lighter or darker than the sky? I'm not concerned with color at all; I'm only observing and assessing degrees of light or dark.

Variation in tone values helps you to describe form, texture, distance, atmosphere, light, and shade. This is why tone is more important than color, though color itself has tone. It's extremely difficult to assess the tone of some colors. Green, for instance, is one of these. However, if you observe your subject carefully and make comparisons as I've suggested, you'll be able to make a more accurate selection of a pastel with the right tone for the green you want to paint.

Monochrome sketches from nature

You'll gain an enormous amount of experience and understanding of tone if you make monochromatic studies directly from nature (*Figure 34*). Sketch simple scenes on the spot whenever you have the opportunity. A light charcoal paper on which you can use a very dark pastel at varying pressures will serve best for describing the tonal effects.

You can also practice these monochromatic studies with a series of gradated tones of gray pastels. Working with a range of grays will increase your knowledge of tone and give you confidence. Remember, each part of your landscape must be expressed in one of the tones of gray. You're working like a photographer using black and white film in his camera; his photographs will translate the color of the landscape into tones of black, white, and gray.

Tonal harmony

An artist tries to create a harmony of tone values in his picture. In fact, tonal harmony means pleasing proportions of light and dark, and the medium tones in between these extremes. Equal areas depicting light, medium, and dark values in a

picture does not necessarily provide the most interesting relationship of tone. In a good color harmony there should be a variation in the areas occupied by tones of the different colors in the composition.

Japanese artists, a century or so ago, gave considerable thought to achieving subtle harmony in their pictures by a suitable relationship between light and dark. They called the relationship *Notan*. I find that *Notan* is an idea that has a greater depth of artistic meaning than our own adopted term *chiaroscuro*. Chiaroscuro is concerned only with the play of light and shade in a picture, rather than with the proportional balance of the values that the Japanese aimed to create.

I hope all this will have helped you to appreciate the importance of achieving precise tonal values. Your work will increase in stature to the degree to which you master this problem.

Tonal values in color

Keeping the context of tone as the subject, it would help if you were now to read again all that was said about the manufacturers' ranges of pastels in Chapter 2. Because all pastels are made in a tonal series, the pastelist's work is different from that of oil and watercolor painters, who have to mix their color until they achieve the desired tone before it's applied. This work is done for the pastelist by the manufacturers; all you have to do is to find the pastel piece of the right color and tonal strength for the area you want to paint. Yet it's not quite so simple as it sounds. Sometimes you can't work directly with one pastel and will need a second pastel to apply over the first one to achieve the correct degree of tone.

Working with color

A well-known Irish doctor attended one of the summer schools that my partner and I conducted in Europe. The doctor, a keen amateur painter, was quick to settle into the group, and was seen spending a fair amount of time in the company of two attractive girls, also members of the party.

One evening while a criticism of pupils' work was in progress, a watercolor by one of these girls came under discussion. One area of her picture was painted in a truly hideous hue. She was asked where on earth she had found the colors she'd used to make it, and she replied somewhat haltingly, "Well, I used French ultra [ultramarine blue], a little light red, some viridian . . . " She paused for a moment, then added, "Oh, yes! And something the doctor gave me!"

There's a great temptation for the amateur to go dipping around in a large selection of pastels, indiscriminately choosing those not yet used in the picture, as if in fear of leaving any out. Also, there are those that I call the "dabbers." They find a color they like, and proceed to dab it thoughtlessly around their picture in a kind of near-panic, hoping, perhaps, that this will revive the work they think is doomed to failure.

The point I'm trying to make above is that you must give the same amount of careful thought to the colors you choose for your subject as you give to the tonal values.

Choosing colors

Before starting a picture, I like to have in mind a fair idea of what it will look like when finished, as far as color and tone are concerned *(Figure 35)*. To do this, I select a number of pastel tints that will be used for the various parts of the landscape. I put trial patches of each of the chosen pastels down on the edge of the paper to be used for the picture. Usually I start at the top, making a color

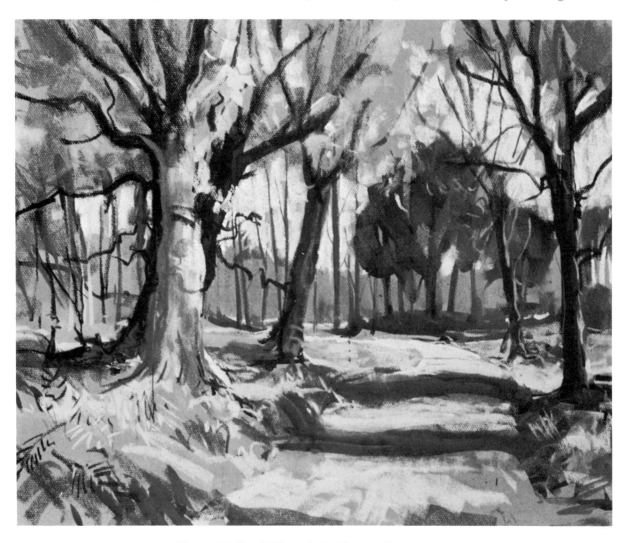

Figure 36. Track Through the Woods, 20″ x 24″, This is a demonstration rough for explaining how the paper tone can be made to work for you. Observe how the middle values of the picture are mainly those of the paper untouched with pastel. To do this, I brushed in a quick layout with nut brown ink on the gray paper, then pasteled with broad strokes, establishing light and dark values in that order. As work quickly proceeded, I constantly squinted at it to judge the building-up of the values, and to keep control of the paper tone by not overpasteling too much of it.

reference with a firm stroke to obtain the true color intensity of each of the tints I'll use in the sky. Beneath these I make tint strokes for the lightest areas, followed by the tints that I'll use for the darker parts of the composition. Normally I use about two dozen pastels to make these color references; then I set these pastels aside until I'm ready to begin work on the picture.

With the various colors lined up, I can now see at a glance what kind of color scheme is developing; if necessary, I make some changes. Then, with my eyes half closed, I study the color patches as a whole, to determine what proportion of the pastels chosen are either lighter or darker than the tone of the paper selected for the job (*Figure 36*). I may decide that there are too few or too many of one or the other; if so, I rearrange my color scheme to strike a better balance.

How papers influence color choice

As you'll recall from Chapter 3, you have to take into account the surface tint and tone of your paper when you select colors for your picture. Ideally, you should choose a paper that will assist you in your work by enabling you to leave predetermined areas of it untouched with pastel, so that they'll show through in your finished work as part of the picture. Usually you should use papers of neutral tints and of medium tone value (halfway between white and black). However, if you feel adventurous and want to work on a highly colored paper, there's no reason why you shouldn't do so. The strong tint will, of course, pervade the whole work and influence all the pastel colors you put on it; yet, the vivid paper can also provide the key to the color scheme. If you're careful, then, about selecting the right pastels to go with the paper, the result should be a harmonious one.

Limited palette of pastel colors

In most instances, it's best to use only as many tints as is necessary adequately to interpret the color mood of your picture. By restricting colors and skillfully exploiting the background tint and tone of the paper, you'll achieve an attractive simplicity. The more you experiment with your materials, the more you'll discover pleasant combinations of color and tone. Very effective little sketches can be made with the use of only two or three suitably chosen pastels.

Practice drills in color

Begin a series of color experiments similar to the sketches just mentioned, using two, three, and four pastels. Then try your hand at selecting ten pastels, and work a landscape sketch on some paper chosen especially for this task. You'll find these exercises are great fun to do, and your inevitable progress in both pastel manipulation and color selection should encourage you.

Personal color schemes

I expect you'll have noticed that I've given no precise advice about the colors you should use in your work. This was quite deliberate. For one thing, judging from the immense variety of color interpretations seen in contemporary art exhibitions, I don't believe that all of us see color in the same way. Secondly, I believe color is a personal thing, and it's really best for the artist to indulge in and experiment with his own color preferences.

Of course, if you're a beginner, choosing colors can be somewhat bewildering. I suggest in this case that you make full use of a pastel manufacturers' landscape assortment of about 90 pastels; this will give you good experience in recognizing and evaluating the various tints. As you become accustomed to the colors, you'll find yourself developing preferences for some over others. In the step-by-step demonstrations that appear later in this book, many of the pastels used will be named for color, and in many instances I'll explain why I chose certain colors to perform a particular task.

Color in landscape

Turner was a brilliant colorist. He also knew how to handle his critics. When one of them, who was viewing a typical work by this English painter, said that he had never seen such colors in a landscape, Turner is said to have retorted, "But don't you wish you had!"

Nowadays, everyone is so accustomed to the eccentricities of the artistic fraternity that you need have no inhibitions about your choice of colors. Of course, you must accept the fact that your color preferences may not be those of other people. Most prefer a ring of truth in pictures, especially in landscapes, for man is generally a lover of nature and dislikes abuse of it. By all means, then, seek an individual style of technique, but let this develop from an honest-to-goodness understanding of the natural scene brought about by constant observation; let your color be in tune with this.

Keep in mind that atmosphere and distance have an effect on color. For example, the grass at your feet can't be the same green as grass a mile away. Yellows tend to get grayer the farther they are in the distance. If you use a pastel color in the foreground and then repeat it in the distance, your picture will consequently lose all sense of recession.

You must also consider the effect of light and shade on color. If you see an orange in good directional light, only about 50% of the fruit is really the true orange color. The rest will be influenced by the light on the textured skin, and by the absence of light in its shaded part. If the fruit is standing on a cool color, this color, too, will cast up a reflection that will further change the fruit's color. This play of color on color is constantly occurring in nature. For this reason you must condition yourself to look for these subtleties and use the wide assortment of muted colors that are available to you (see "Tonal sets of pastels," Chapter 2).

Figure 37. Village Pond, 19″ x 25″. "Roses 'round the door" may make us love Mother more, but the overworking of too much sentimental trivia can make your pictures look *too* pretty. The danger of this can be avoided by adopting a broad, direct approach with pastel, omitting much detail, and concentrating on a lighting effect or a muted color arrangement. I used the direct approach in this study, and made use of the bright sunlit wall to introduce the village gossips at the focal point of the picture.

6. Mastering Techniques

Now let's go through all the stages in pasteling a landscape from start to finish, beginning with subject selection.

Subject selection

Many leisure painters have difficulty in selecting subjects for pictures (*Figure 37*). I once had an Australian pupil who enrolled in one of my painting schools a day or so after his arrival in England. The first morning of the course, the group was taken off into the beech woods to paint. Though an accomplished watercolorist, our new overseas colleague had never done much field work, and at the end of the day I overheard him talking to one of the others in the group. His remarks—in a lovely Aussie drawl—went something like this: "I tell yer, mate, it fair shook me to be dumped in a wood, ruddy trees everywhere, and he calmly says, 'Now you find yourself a subject, and get on with it.' Cor, stone the ruddy crows."

In some ways it's fatal, especially if you're inexperienced, to go out on a sketching trip with a preconceived notion of what you want to paint. Generally you won't find the subject you have in mind, and you'll just waste time and energy looking for it. You just have to face it: the ready-made subject rarely exists as a complete composition. Out of the great panorama of nature, you must select and often rearrange the components to suit your design. Random sketches crystallize your thoughts, and the essence of these should be distilled for your picture.

I like to make "sketching reconnaissances" of a particular area I want to paint. I go to the place and make numerous little black Conté sketches about 4" x 5", using my finger to rub in a little tone to show how the values will be organized. Sometimes I use a Pentel or 6B graphite pencil to draw in greater detail a part of the landscape that particularly interests me. You'll see what I mean if you turn to the earlier chapters and examine my sketch material. This activity sets the pulse running, and the idea for the picture usually emerges. I find myself

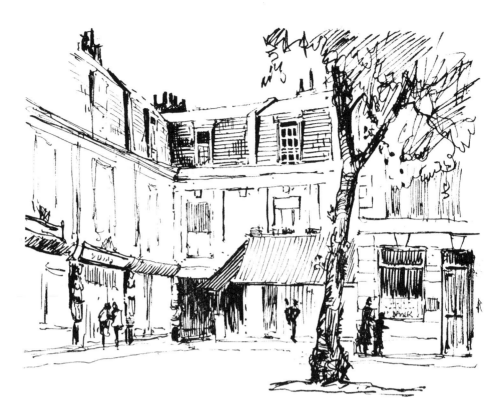

Figure 38. This little sketchbook jotting, made with a Japanese Pentel, is the kind of thing I do when I'm in search of subject matter for pictures. I found the regency architecture of this corner of Cheltenham of great interest so I made a note of it.

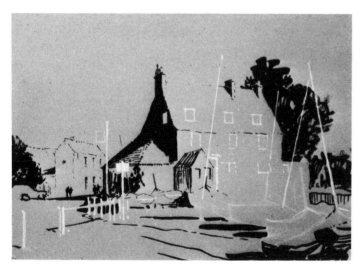

Figure 39. Boats by the Inn. (Above) Because of the lighting effect prevailing at the time, I made an unusual draft for this, using black and white waterproof inks with a brush on a deep gray paper. The black ink, strongly used in the shaded areas, builds up the design of the picture.

Figure 40. Juliet's Balcony, Verona. (Right) Only the very jaded can escape a thrill of excitement on entering this courtyard in Verona, Italy. I used hard pastels for this pastel layout but it never got beyond the starting stage.

thinking of suitable backing papers, and even about tone and color; then I imagine the effect that I'll create in the finished picture.

I strongly suggest that you undertake some "sketching reconnaissances" of your own (*Figure 38*). The sketch material that you collect in the field may often seem of little consequence at the time. But since the sketches have been made from observation, you'll find that later they'll recall to your mind innumerable impressions, formed perhaps subconsciously, of the occasions when you drew them. In short, they'll provide you with a store of visual memories that you can draw upon for your studio work.

Also, to be a successful landscape painter, you must cultivate a sharp awareness of what makes suitable subjects for pictures. Do this by making it a habit constantly to observe the landscape around you, even when you're going about your normal daily tasks. The mental exercise of trying to figure out how you'd handle the problems of composition if you were to paint the things you see will enormously improve your concept of pictorial design, even though you never actually paint the subjects you're pondering.

Subjects for pastel

Undoubtedly the easiest subjects for pastel are those that have a good contrast between light and dark, and those that can be treated in a broad, direct way. Complications arise when you overload your drawings with a mass of architectural or other detail, so ways and means have to be found to simplify them. However, no matter what subject you eventually select, it has to be well composed. The success of your picture will ultimately rest upon your skill in selecting a subject, the originality that you put into its conception, and the way you've handled its compositional arrangement. No matter how competent you are with your technique and color choice, a weak composition will kill your picture.

If you have to strengthen your ability to compose—that is, to arrange all the elements of your picture in a pleasing, well-balanced way—make a concentrated study of this particular aspect of your work. A great many books deal with the subject of composition, and you should take every opportunity to visit galleries and exhibitions to see how the other fellow coped with the problem. To help you, I have included in the Appendix a list of specialized books on composition, perspective, color harmony, etc., that should be useful to all landscape painters.

Starting the layout

If you followed my earlier advice, you've been on "sketching reconnaissances" that have resulted in your drawing several small tonal roughs. You've chosen the best of these roughs for your subject matter, settled in your mind the matter of composition, and decided on the tone and color of the paper you'll use. So now you're ready to lay in the draft for the picture.

Figure 41. Quiet Canal, Venice, 15″ x 22″. Architectural subjects such as this demand careful drawing before pasteling. I used a brown Pentel to do this starting layout. Since most of the line work would be obliterated by subsequent pastel work, I wasn't bothered that the ink from the Pentel would be quick to fade.

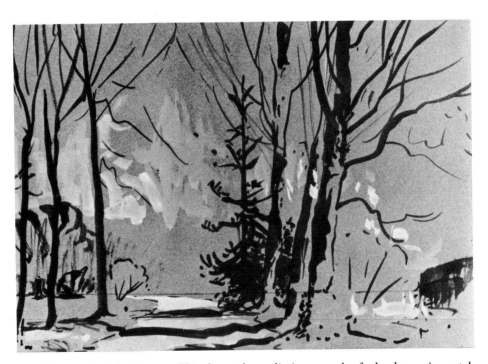

Figure 42. Sunlit Avenue. This shows the preliminary work of a landscape in pastel, using an underpainting of ink and gouache. I used a gray charcoal paper and set the design with brush and brown waterproof ink. The ink-line drawing indicated the darker tones of the picture. I used the gouache underpainting for the lighter parts of the sky, and for the sunlight on the road and in the foliage of the trees.

The initial drawing for a picture in pastel can be drafted in several ways; it's usually done with charcoal, Conté, hard pastel, or even with a pencil (*Figures 39 and 40*). There is no point in being overelaborate with this part of the work, for the function of the draft is merely to sketch out the composition in preparation for pasteling. To enlarge a small sketch, you can use a grid system to blow it up in true proportion. I rarely do this, however, because sometimes I decide on a last-minute alteration in the design which I think will improve it. When this happens, that which appeared pleasant enough on a small scale may not fit in with my ideas for a larger work.

As I said previously, I frequently draft a picture with a black or brown Pentel. I use these when the subject requires more than a usual amount of detail, especially in architectural subjects (*Figure 41*). I prefer a brown or black waterproof ink and a sable brush to make my first drawing—especially if I'm planning to use an unusual backing or underpainting. A wash of watercolor or gouache won't disturb the lines made by waterproof ink, but it would ruin lines made by a Pentel. The reason, of course, is that the ink of the Pentel isn't waterproof; besides, its color will fade quickly. Waterproof ink, on the other hand, is not only permanent, but its color lasts. If you want to use the Pentel for a draft, though, it's quite all right, since the opaque pastel will cover it, anyhow.

Since I've mentioned the opacity of pastel, this seems a good place to point out that it's not necessary to remove any errors in your initial drawing. These won't be seen in the finished work because the pastel will cover them. Of course, you have to remember which are the wrong lines, and work only with the correct ones.

The underpainting

Your method of working a pastel picture is largely determined by the color and tone of the paper you use. If you've selected a dark paper, and a considerable area of sky has to be drawn in, you'll save time if you rub a very light-toned, gray-tinted pastel into the sky area with a pad of absorbent cotton. This will "kill" the dark paper tone, and make the rest of your direct pasteling much easier.

You can also alter areas of the paper color and tone by overlaying them with gouache before you start pasteling. This, too, is a timesaving method that you can use for subjects that have extreme contrasts of light and dark. An example of a subject for which this gouache overlay is suitable would be a woodland flooded with sunshine. The areas of bright light, i.e., the sky seen through the tracery of branches and strong, bright passages of sunlight shining on the leaves or tree trunks or running across a path—all these can be put in with gouache. Figure 42 shows a painting that was made in this way.

Pastel and gouache go well together, for when applied somewhat heavily they're both opaque media. You can buy designers' gouache by the tube, and you probably won't need any more than about a dozen colors to use for pastel

backings. A good selection would be as follows: white, mid-yellow, yellow ochre, vermilion, light red, alizarin crimson, ultramarine blue, phthalo (phthalocyanine) blue, raw umber, burnt umber, viridian, and black. Use them with water and normal watercolor brushes.

Underpainting with watercolor

You may be planning to use white paper for your pastel picture; if so, you're going to find it extremely difficult to work on with pastel. Some areas of your work will need a tonal backing. You can do this either by rubbing in a tinted pastel (this time to kill the light) or, as I usually do, by covering the whole surface with a watercolor wash. There's no need to go to the extra expense of getting watercolors in tubes for this purpose if you have the gouache colors suggested previously. These gouache colors can be used for transparent washes merely by adjusting the amount of water mixed with the pigment. The more water, the more transparent the wash.

As you can see, then, it's possible to paint an even-toned wash across a whole sheet of white watercolor paper in any color that suits your purpose. Or, if you wish, you can vary the tone and color in this wash to give areas of color that you can make use of when pasteling. Obviously, there's not much point in using a transparent watercolor wash on a tinted paper, for its effect would be barely noticeable. This is why gouache is used for this technique on tinted papers.

I'm sometimes asked if there's a limit on how much watercolor and gouache can be used for a work that is intended to be a genuine pastel. I think you can do as much work as you wish with these wet media; but for a picture to qualify for exhibition in the pastel category, at least 80% of its surface should be covered with pastel.

Pastel procedure

There's no set rule on where you should start working into your picture with pastel. It all depends upon the kind of tonal backing you've selected. Normally, you'll work on a middle-toned tinted charcoal paper, with a simple draft indicating the layout of your composition. In these cases, it's best to decide what parts of your paper are going to remain untouched with pastel; then use these untouched parts as guides for judging the tones of the rest of your work.

You'll recall my mentioning earlier that by the time I'm ready to start a picture, I've already selected about two dozen pastels to use as color references. Now, with these for guides, I'm ready to begin work.

I usually start with the lightest tone for the sky, generally at the horizon, using considerable pressure to work this into the paper in order to get the true value of the pastel. If your sky is a light one, i.e., higher in value than the general landscape, it's no use messing about with tentative and hesitant strokes. You can't

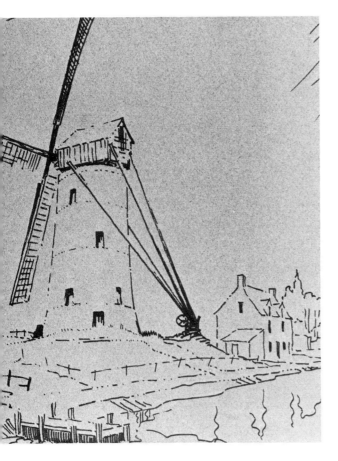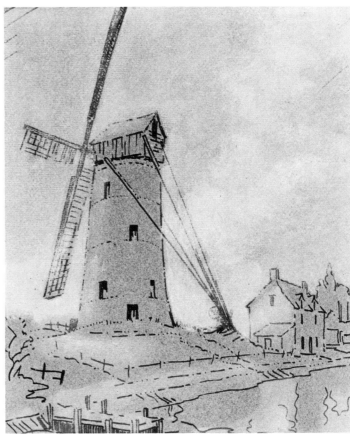

Figure 43A. This sketch of a windmill at Damme, Holland, demonstrates the normal method of attacking a pastel painting (see *Pastel painting procedure* in Chapter 6). It helps to have good layout drawn in any way you choose. This one was made with a fiber-tipped Pentel. I made the original sketch one very wet day in Holland last year, sitting in a bivouac improvised out of a tripod easel and raincoat, to set an example to my pupils, whom I've always told that bad weather shouldn't stop the work. This show of determination in the face of the elements was, I discovered later, of no avail; for by the time I'd finished, they were regaling themselves in the local café.

Figure 43B. I decided that the skeleton of the mill would be represented by the gray-green tint of the paper. The sky was pasteled with very light gray and pale yellow ochre where there were sunlit clouds. This was rubbed in with absorbent cotton; then the pad, still containing pastel dust, was passed gently over parts of the landscape which had a value lighter than the paper. All this helped to set up a scheme of values.

get anything lighter than the lightest pastel chosen, so really press it into the grain of the paper.

I do perhaps a half to a third of the horizon, throwing it up prominently. Then I select the next darker tone for the sky, and work with the two pastels together at full strength to begin the gradation of the sky tone. Depending upon the characteristic of the sky, I work upwards for about a third of it.

Now I switch from the incomplete sky, and look for the lightest value in the landscape itself. From the preselected assortment, I use an appropriate pastel and work this strongly into the lightest landscape areas (*Figures 43A and 43B*).

My next selection is the darkest pastel from the assortment set aside for the picture. I do some work with this where the lowest tonal values occur in the composition. Just a few strokes suffice, for I can now see how the picture is coming along as far as tone value is concerned. Now, by squinting at the work that's already been done with light and dark pastel, I can judge the value of the paper that's still untouched. It's then a matter of approaching the work as a whole, never concentrating on one area at a time, but giving attention to the all-over design. My final effort is concentrated on the picture's center of interest.

The start I've described is a conventional one. It can be adapted to cover any kind of backing. When a very light paper is used, it may be better to begin with mid-tone darks. You know then that you have your extremes of light and dark pastel in reserve.

The important thing is to know when to stop. It's always best, and safest, to leave off before you think you've finished. So many pictures are spoiled by a constant dabbing about with the pastel to give the picture the so-called "final touch." If you don't restrain yourself from making "just one more dab," the picture will begin to look weary and overworked. Fortunately, my wife, Marjorie, has an eye for a picture. It's a great help to me when she says rather firmly, "Don't do any more, you'll ruin it." Sometimes we need to be saved from ourselves.

One way to determine when the end is in sight is to "preview" the picture. To do this, keep a mat handy and lay it on your picture as your work progresses. When you see the effect it produces, it may prevent you from putting in too many of those last-minute, unnecessary—and possibly disastrous—touches. There are many step-by-step demonstrations to come later. These will describe alternative approaches which will be helpful to you.

Not all work can proceed at full pressure on the pastel; but to start, you do need to register some of the strongest light and dark passages as soon as you can. Afterwards, pastels can be used in tentative fashion, for if the grain of the paper was not filled the first time, a second pastel can be stroked over a first. There's a limit to the amount of pastel the paper will hold. Once this limit is reached, any overworking on it produces unpleasant, smeary marks. These must be avoided at all costs; they look very amateurish.

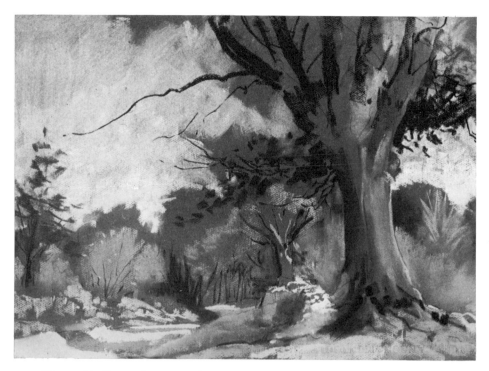

Figure 44. Correcting a pastel is easy. The offending pasteled area can be quickly removed simply by brushing it off with a stiffish bristle (hog hair) brush. Any stain from the previous pasteling that remains can then be removed with a well-kneaded putty eraser. Never overpaint a mistake. This illustration shows large areas of the trunk of the tree that have been brushed off, ready for repasteling.

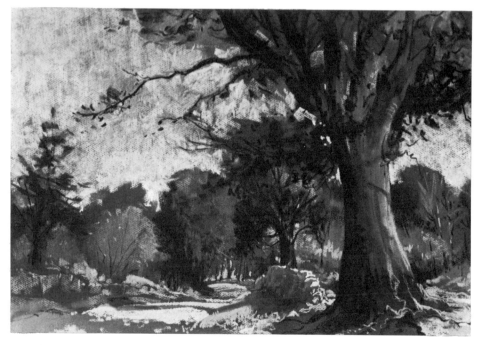

Figure 45. Beech Tree, 15″ x 22″. In correcting this picture, there was no need to remove the stain left after the brush-off. You'll see how I repasteled all these areas with crisp strokes and, in parts, allowed some of the stained area to show through. This assisted the final result, much in the same way as does letting the original paper tint show through our work.

Erasing and correcting pastel

It's really easier to make corrections in pastel than it is in any other medium (*Figures 44 and 45*). You can change your mind, lift the color, and continue to make changes all the while that the work is in progress. It's a comfort to know that you can be as bold as you wish with your treatment because you can easily take off what you've already done and do it again. What's more, the effects of these corrections won't be seen in your finished work.

Here's how the lifting procedure is done. Sweep the area to be removed with an old, stiff bristle (hog hair) brush; as you do so, blow away the pastel dust. Be sure that you get all the pastel out of the grain of the paper. You'll now be left with a stained, mottled surface, but this means nothing. Often this unpleasant-looking surface turns out to be just the right backing you need for laying on some nice, crisp pastel strokes of the color and tone required. If you want to restore the original paper color, you can remove the stain by rubbing it with a kneaded putty eraser. Always keep the eraser well kneaded between your fingers, so that it feels tacky. When it's in that state, it will easily lift up unwanted pastel dust and remove any stain.

It's also possible to scrape off small areas of unwanted pastel with a penknife; this is similar to the customary way of using a palette knife to remove oil paint from a canvas. Or you can use small brushes for this lifting work; I generally prefer brushes to any other method.

When your pastel picture is finished, turn the board on which it's attached on edge, and give it a few sharp raps on the floor. Any loose particles will then be dislodged. Once they're cleared away, you'll be in no danger of soiling your work when you cover it with a protective sheet of smooth paper.

The demonstration pictures

We've discussed the variety of pastel approaches and the immense possibilities of still further investigation into pastel techniques. Now let's consider some of the problems that arise in the treatment of various landscape subjects; these, natural-ly, will depend on the subject matter that you select for your pictures.

After a brief introduction to skies and distance, the essential elements of landscapes, the next part of this book will deal exclusively with demonstrations les-sons that you can do yourself. They will be based on the main components of the landscape picture. These pictorial exercises are calculated to take you step by step through the process of pastel painting of subjects that you'll undoubtedly want to tackle when you're on your own and faced with producing original work.

If you're new to pastels, I suggest that you work through the following examples, choosing for your papers a tint and tone similar to those recommended for each study. Do each work three or four times larger than the printed picture. And a word about the illustrations in the book—an ideal way to examine them

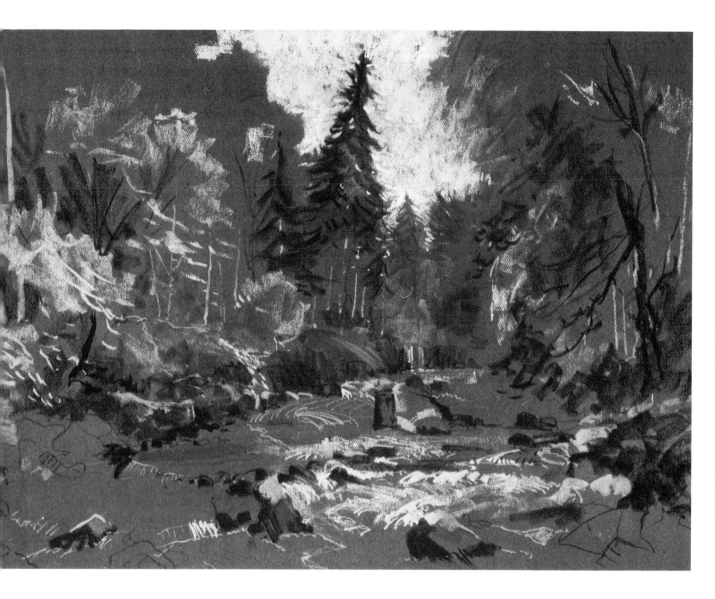

Figure 46. Study of Water Movement, 22″ x 30″. This was a class demonstration sketch to illustrate my trend of thought when tackling such a difficult, ever-changing subject. I used a very dark gray Canson No. 345, and I drew in the composition with a gray Othello pastel pencil somewhat darker than the paper. This first layout described the shape of the river bed, the rocks strewn across it, and the trees massed behind. I then made a special effort to describe the flow of the river, using a light gray, hard pastel. I drew the direction for all the main planes of the water's descent, beginning with the waterfall, including the shape of its falling, curling, and gushing as it dodged between rocks and crags. This procedure made it easier to identify the water's lights and colors. Next, I made a start on the rocks in the water, and the steep, clifflike edges of the turbulent stream. Allowing the dark gray color of the paper to represent distant trees, I then forced the light into the sky. Finally, I began a description of the various trees on the banks, giving accent to the lighter foliage and to the treetrunks that caught the light.

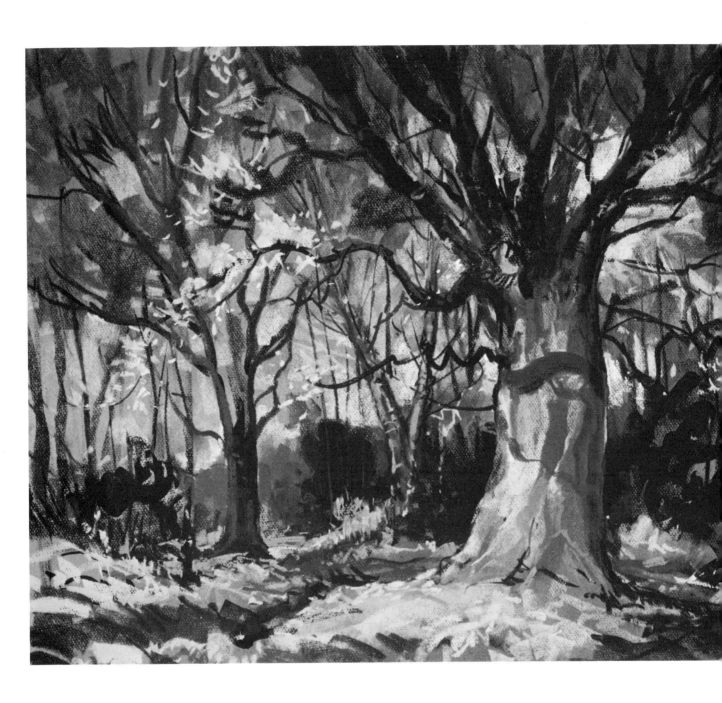

Figure 47. Autumn Woods, 20″ x 24″. On an amber-colored paper, I drew a brown ink draft for the composition. For the gay colors of the fall, I used a full range of tints which contrasted with the purple-grays of the distant trees. The whole study proceeded vigorously, for my intention was to get the colorful mood of the fall, rather than to detail every fern and bracken leaf. For this reason, the foreground is an impression, and somewhat out of focus.

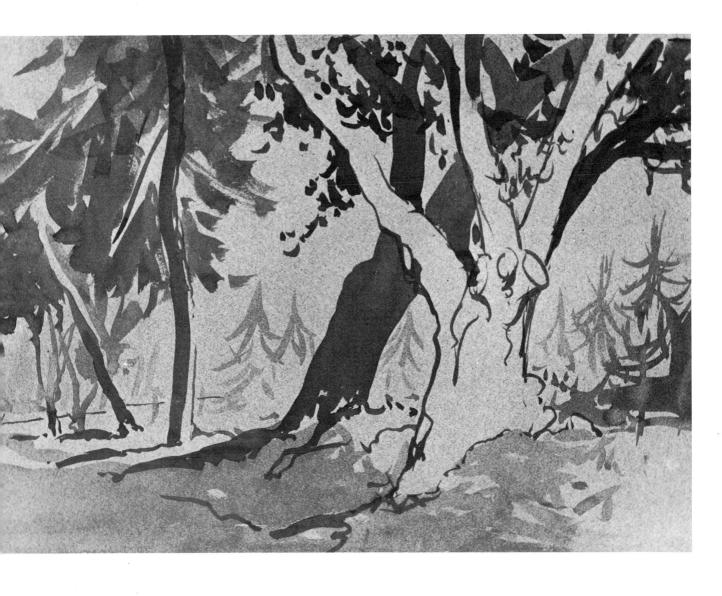

Figure 48. This line study of trees was made on location with a watercolor wash. It provided the subject material for Demonstration 3.

more closely is through a magnifying glass. A magnifier will give you a better visual idea of the stroke technique I used in the original artwork. On the other hand, if you're somewhat experienced with pastel, don't copy the demonstrations; instead, choose subjects of your own that are similar to them, and use the demonstrations only as a guide.

I've chosen a representative group of landscapes for these demonstrations, and focused on those elements of natural scenes that habitually create problems for the amateur. They're not arranged in order of their difficulty of execution. Rather, they occur in the natural order of things and include skies, mountains, water, and rocks (*Figure 46*); trees and woodlands (*Figures 47 and 48*); winter landscapes (*Figure 49*); old buildings (*Figures 50, 51 and 55*); buildings with water (*Figures 52 and 53*); marine subjects; and interior "landscapes" (*Figure 54*). Finally, we'll consider the importance of figures and other objects in landscapes. So, get your gear ready. We're off on an exciting sketching trip around Europe!

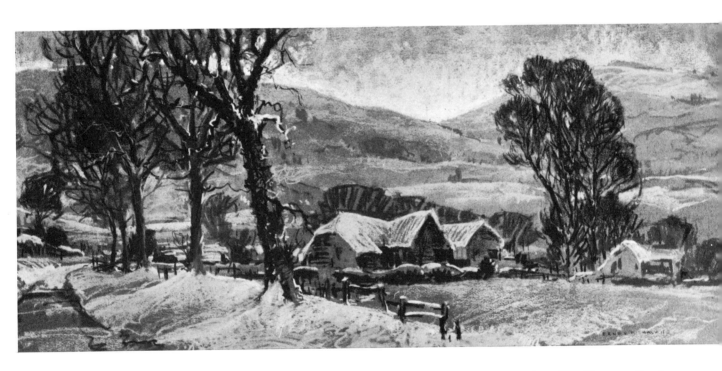

Figure 49. Winter Landscape, 13″ x 29″, Pitman collection. There's a tendency on the part of some pastelists to make snow effects too dazzlingly white or, sometimes, too blue. You can always resist the very first temptation to do this by hiding all your white pastel, and using it very sparingly later for foreground accents. This study from my studio window was done on thin charcoal paper, Canson Ingres No. 55, which is a pale gray. The paper was left untouched for some of the passages in the picture, particularly those on the hills and in the tree branches. I like to compose landscape pictures in rectangles of many proportions. It's good to go for variety of this kind for normal work, for it keeps your compositional skills alive.

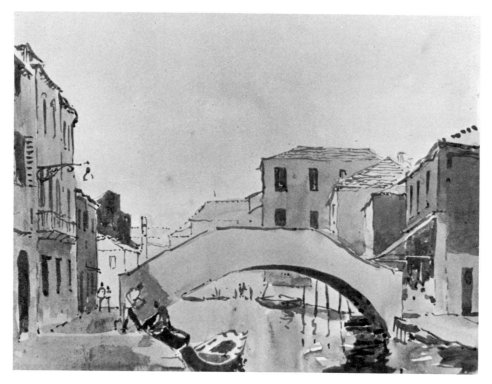

Figure 50. Burano. This line drawing, made with watercolor wash, was done from the central bank opposite from that used for the painting in Demonstration 6. I'd walked away from the bridge, and made a sketchbook note with a black Pentel, which shows more of the canal.

Figure 51. Burano. This Pentel line sketch is included as an alternative composition of the subject chosen for Demonstration 6. You could use this sketch and Figure 52 to pastel pictures of your own in the manner of my demonstration sequences.

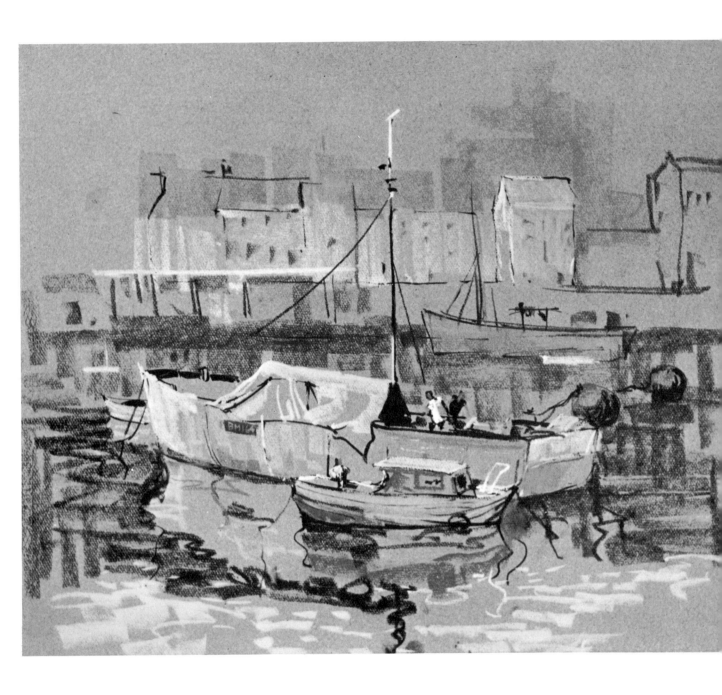

Figure 52. As I describe in Demonstration 7, I strolled around the harbor to collect subject material. This particular group of boats looked good to me. So up went the easel, and onto a 20″ x 24″ sheet of gray paper I sketched out a likely composition. I explained to the pupils that I was concentrating on the boats tied up to the large, round, rusty buoy. On this account, I was ignoring the row upon row of cottages, climbing the cliffside behind them. Those cotttages beyond the first row were put out of focus and only an impression of them was given with blocks of tone. My aim was to keep everything lively (both drawing and pupils!), so this rough start took little time. You'll find this type of sketch invaluable.

Figure 53. Eilean Donan Castle. This was a sketch with black Conté made during the study for Demonstration 2, *The Sentinel of the Loch.* There were so many interesting viewpoints from which to make pictures of this old castle that choosing one was difficult.

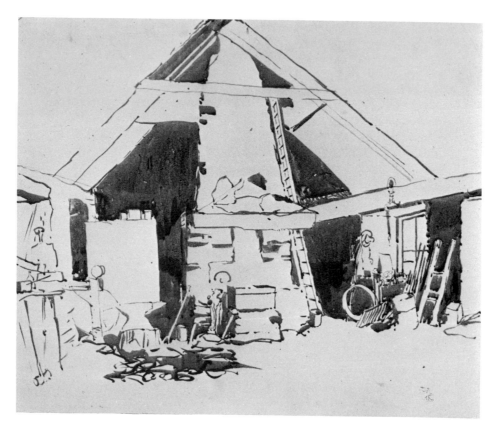

Figure 54. The Old Forge. This is the original sketch made of the old forge in Wembury which I pasteled again for Demonstration 8. I was dissatisfied with the composition in this sketch because I felt that the forge chimney was too central.

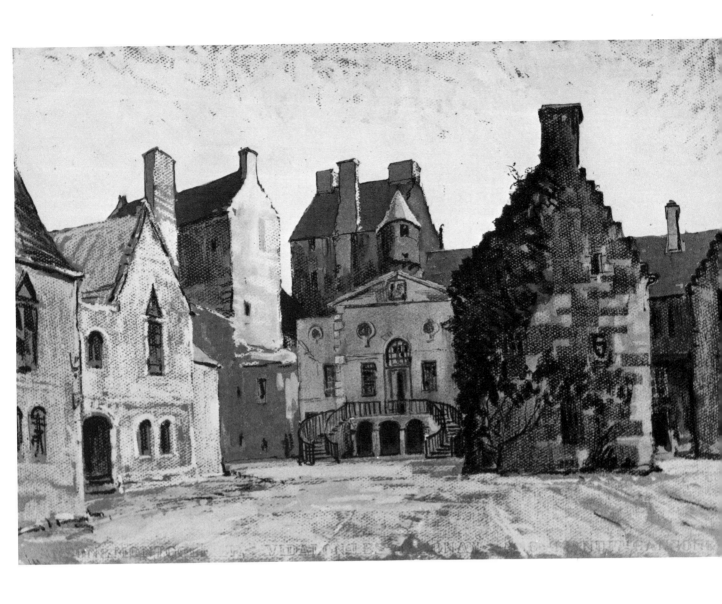

Figure 55. Murthley Castle. This is where I met Adrian Lamb making a facsimile painting of an early American master-piece. You can see the castle is a grim but noble building. It remains the family residence of the laird whose ancestor was depicted meeting a tribe of Indians. After an initial line draft with brown ink, I started the picture with a gouache underpainting for the sky. Pasteling followed, but all had to be hurried, for I had another castle to visit that day.

7. The Essentials of Landscapes

I've been told that when I'm giving public demonstrations, I'm like the vaudeville comic who brings an instrument on stage, and then goes through his gag routine of making only casual attempts to play the thing. He never quite gets around to playing the instrument until winding up the act.

Be that as it may, I always find that there's so much to *tell* people about painting that I end up with little time left to *do* any. An anecdote often gives just the emphasis necessary to a point that I want to get across, and though I usually rush the demonstration at the end, I emerge out of the pastel dust with the work framed up. (Applause!) Now that I've explained my "style of delivery" to you, I trust you'll bear with me if, *before* beginning the demonstrations, I first talk to you a bit about skies and distance.

Sky

In a way, the sky is always the most important component of landscape, so it will be the dominant feature in a great many of our paintings. Since the sky, by means of the sun, is the source of light, it affects every other part of the landscape. This is true even though there may be little of it in our pictorial composition. When only minor glimpses of sky can be seen, its tone value in relation to other parts of the picture is the thing that's important. Therefore, small areas of sky, or skies behind busy landscapes, should be kept as simple as possible. A greater knowledge of the sky is necessary, however, when it comprises, as it often will, more than half your picture, either as a cloud pattern or as just a simple gradation of color for a cloudless effect.

I don't believe the average amateur devotes enough study to the wondrous changes that take place in that vast astral dome above our heads. Nor do I think he gives enough attention to the subtleties of the sky's tones and tints. If you want to be a serious landscape painter, you must be constantly studying and making color sketches of the sky—this is what the famed John Constable spent a

lifetime doing. What's more, you should by all means read some books on meteorology, so that you'll become better acquainted with scientific data about clouds and their formations. The more you know, the better you'll paint.

Recession in skies

There can be no rule of thumb for sky painting in any medium. Each sky you tackle will be a fresh experience. You must therefore work at it in your own way, while also studying the works of others to see how they've tried to solve similar problems. This doesn't mean, however, that I can't help you with some fundamental elements that have to be evident in sky painting. For example, there is generally a darkening of tone value in the sky as it reaches upwards over our heads toward its dome, or zenith. Also, there's a lightening of values as the sky stretches away from us into the distance, or horizon. You'll find it helpful if this change of tone value is somewhat obvious; it gives the effect of recession.

Cloud formation

If you depict a tree in your picture, I'm sure you want it to be recognizable as an oak, palm, fir, or whatever. You should strive for this same authenticity when you portray clouds, so that cumulus, nimbus, cirrus, and any of their other forms can be identified. Strangely enough, I find that while the student landscape painter readily acknowledges the necessity of making a tree look like what it is, he too often leaves his clouds to chance.

Sky colors

In pastel work, subtlety of color in all but the most dramatic of skies is of supreme importance. Beware of using too harsh or too bright a blue. Temper your blues by blending them with pearly grays of a similar value. When you're painting an extensive sky, ring the changes from the horizon to the zenith with many closely related pastel tints. Blend these in a random pattern of small color patches instead of using one pastel tint for a large area. For greater subtlety, remember to manipulate your sky pastels at varying pressures.

Relative value of sky and earth

The ultimate success of a sky painting depends upon the adequate portrayal of the tone value of that part of the earth or horizon that meets the sky. For this reason, even when you're doing the sketchiest roughs of skies, always include an indication of the tone value of the earth immediately below the sky. The tone value of the distance is a variable factor, depending upon the time of day, the direction of light, the effect upon it of cloud shadows, and so on.

Plate 1. Paper Color and Pastel. These three sketches were each made with only two contrasting pastels. First a brown paper was lapped over a gray one. Then the long panels were pasteled with two pastels, ignoring the fact that there were two different grounds. Notice the difference in each pair of sketches caused by the two tinted papers used. See how the brown shade of paper has given warmth to all the left-hand sketches, and how coolness is evident in the right-hand ones. Notice too how a change in value can be expressed with one pastel by varying the pressure applied to it. Thus, the harder we press on light pastel, the lighter the tone. The opposite is true of dark pastels.

Plate 2. Pastel Techniques. Here are some ways of using pastel. (1) Strokes are made with the side of the pastel, which is held between the index finger and thumb, so that broad areas are covered at one time. This is the basic method of using pastel. (2) Should a change in tonal value be required, you can fill the area with randomly placed strokes, some of which may overlap. This can also be done with several pastels and the colors can then be blended. (3) Here the pastel was used on its end as in a linear technique, or on its side for braoder drafting. Use this method for drawing. (4) This sketch is an example of both area and linear pastel-stroking, a combination which is more generally used than any other. (5) This study was made with a combination of all the techniques described above.

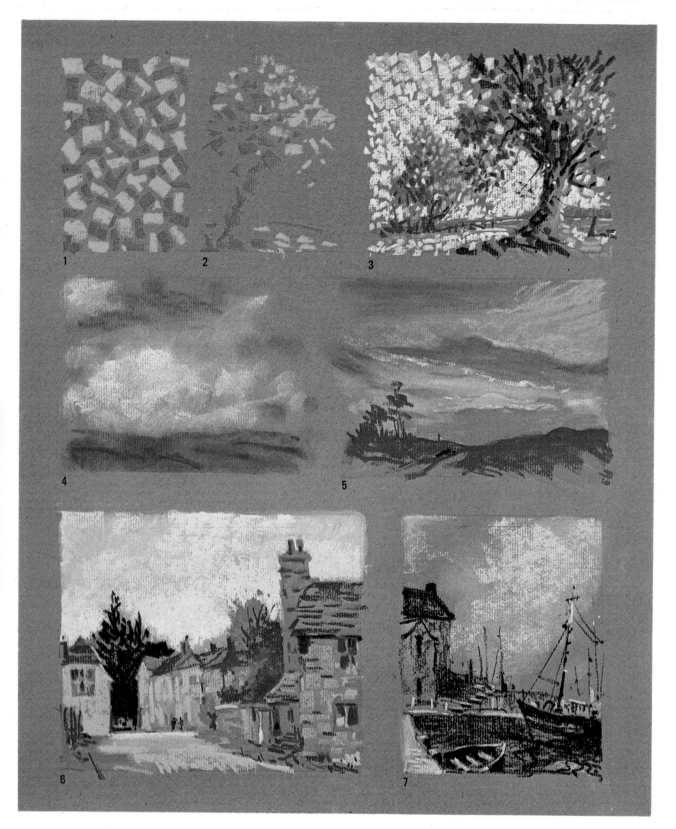

Plate 3. Pastel Techniques. Here are further ways of using pastel. (1) Spots of color were made with the pastel end to produce a pointillistic effect. (2) A controlled application of the color patches as opposed to random placing, improving the description of light and dark in the tree study. (3) An example of how the pointillist can produce subtle changes of tint and tonal values, and give added brilliance to the light. (4) A rubbing technique was used for blending tints in order to overcome the effect of the paper color and texture, and to form an underpainting for subsequent pasteling. (5) The rubbed effect was overlaid with direct pastel strokes. (6) This sketch and sketch (7) were made by using only two shades of burnt umber—one very light, the other very dark. (7) Your understanding of tonal values will improve if you do many monochromatic sketches like these.

Plate 4. Sunlit Avenue. My procedure in this painting was a loose and direct pasteling. First, holding the pastels on their sides, I made broad, bold strokes with greens and purples to indicate the massed shadow effect of the foliage. I used some of this same tone for the distant trees to the left. Second, the conifer was portrayed with deep green-gray that turned purple at its base. Blue-gray was then substituted to run over the tree shadows across the road. Third, using firm pressure, I gave attention to the sun patches on the road the light grass verges. Following this, I worked on the right-hand tree trunks and the growth above them. Finally, I gave accents of light to the sunlit foliage, using bright, yellowish green over the previously painted areas; then, with the strongest darks I picked our various branches for contrast. The tint at the bottom right-hand corner is approximately that of the paper, much of which shows in the finished picture.

Plate 5. Boat Houses, Dell Quay, 22″ x 30″. This was a class demonstration to illustrate a number of pastel techniques. I rendered the sky with random strokes, using 10 pale tints that I gradually blended to record something of the cloud pattern at the time, and also to give the effect of recession by a subtle change of tint and tone. It helps in the portrayal of buildings if the stroke technique follows the line of their structure, or runs according to the perspective. I used the pastel in vertical strokes on the walls of the main building, and lifted it in those places where there were window and door recesses. The strokes representing the planking on the lumber-clad sheds followed their structure and perspective. The foreground was pasteled broadly and not overpowered with detail. The strip of light in the middle of the water helps to lead the eye into the picture and past the walking figure.

Plate 6. Wind over the Loch, 15″ x 22″. This was a demonstration picture composed from the view through the window of a hotel in Scotland, when inclement weather confined the class indoors. The distant mountains are on the Isle of Skye, and the road is the one made famous by the Scots' song "The Road to the Isles." The broad pastel strokes used in the sky and in the group of foreground trees was an attempt to capture the movement of the wind. Pastel is grand for a quick effect like this; the whole job took only about an hour. This was a direct pastel from start to finish. Even the layout draft was put in with the pastel.

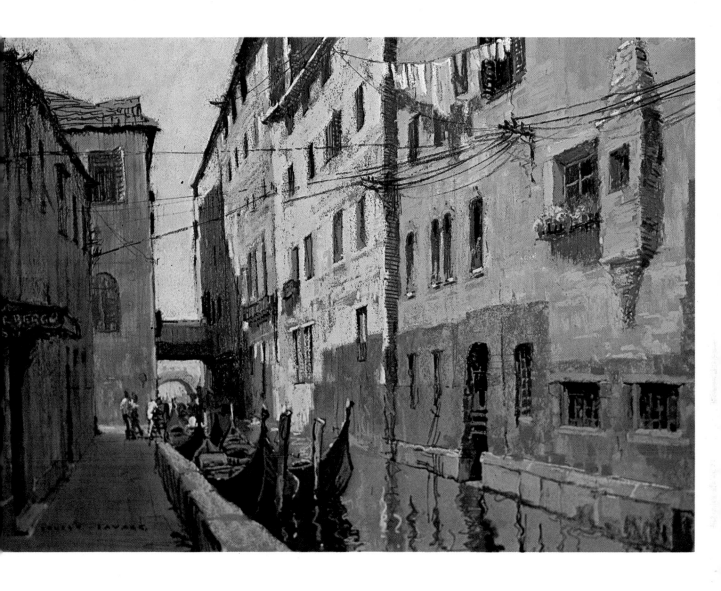

Plate 7. Quiet Canal, Venice, 15″ x 22″. Starting from beneath the bridge and working upwards, I pressed very pale purple-grays into the paper to obtain the brilliance of the sky. This immediately threw up the silhouette of the tall buildings and began to create the recession I was seeking. I next used a gray tint of a tonal value to compare with the shadow cast from the left to the right building, above and below the covered connecting bridge between them. Now it was possible to introduce more light tints on the sunlit walls; to tell something of the ancient weatherworn brickwork, windows, and balconies; and to take down to the water any parts reflected there. Using purple-grays and green-grays, I pasteled the darks of the gondolas and their reflections. The darker values of the buildings to the left and their doorway recesses were now added. To complete the picture, I put in the electric and telephone wires, wrought-iron grills, and the figure group.

Plate 8. Old Farm Buildings. (Above) These old farm buildings are situated near the Tudor cottages that provided the subject matter for Demonstration 5. The method of pasteling was similar for both pictures. In this case, I used dark gray Canson Mi-Teintes paper and I made a bold brush line layout with black India ink. Work started with the bright sky at the horizon. Next, the lighter values were put in elsewhere. Then I concentrated on the dark values. To complete the painting, final accents were placed.

Plate 9. The Green Quay, Bruges. (Right) Bruges is a beautiful city. It's often called the Venice of the North, because of its many canals and bridges. Life here is still quite leisurely, and since subject matter abounds at the turn of every corner, it's a lovely base for a sketching group. I began this picture with a charcoal draft on steel gray Canson Mi-Teintes paper. Following the normal procedure, I started on the sky, then switched to the darks. I chose this subject for my painting group to show ways of handling reflections. These were described in Demonstration 7.

ERNEST SAVAGE

Plate 10. Sailing Barges at Pin Mill, 19″ x 25″, Private collection. What a find it was to come across three old Thames sailing barges at one time! There are less than 20 of these ancient craft left in Britain today. Once they plied the coast with large cargoes of grain, lumber, and coal, with a total crew of two—a man and boy. They're large, simple boats, well suited to the pastel medium. You'll notice that I made full use of the pale blue-gray paper, mainly to represent the sky, but also to introduce just a little light at the horizon. This tranquil sky enhances the design of the masts and rigging, giving the picture an "easily done" look. The fact is, however, that quite a lot of thought went into it.

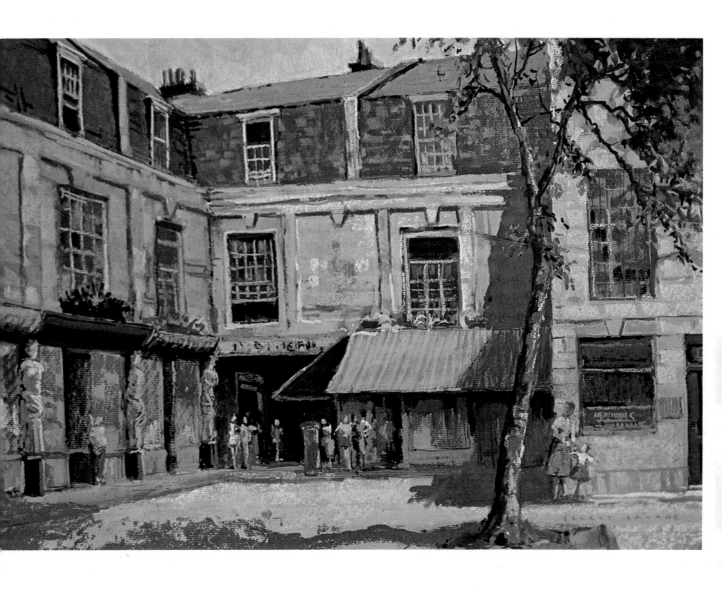

Plate 11. Regency Cheltenham, 15″ x 22″, Collection Captain J. R. S. Brown. This was a straightforward subject, and I took care to use a minimum amount of detail to describe the architectural features. I emphasized the excellent contrast between the blue-gray slates on the barrel roofs of these Georgian buildings and the creamy brown walls of the Cotswold limestone that was used to build them. Figures were necessary to bring the composition to life.

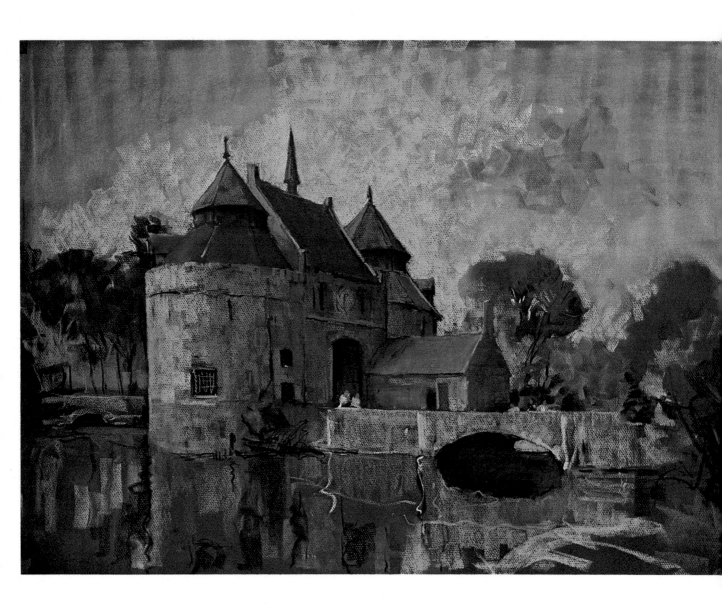

Plate 12. Medieval Gateway, 20″ x 32″. This is the Ostend
Gate, Bruges, once a part of the city's fortifications. My
procedure was as follows. An accurate line drawing of this
ancient building was made with a gray layout chalk on very
dark gray paper. Then I decided to have a simplified sky
effect to counteract the intricacy of architectural detail.
The sky was therefore blocked in with a number of pale
tints that blended as the strokes proceeded from the
horizon to the zenith. I gave a similar loose treatment to
the distant trees, and took care to provide an interesting
sky line above them. Now I attended to the building itself—
first working on the lighter masonry, and immediately
indicating in the still water beneath them the reflections of
the parts already done. Last, I put in the final accents,
impressions of figures, and flashes of light in the water.

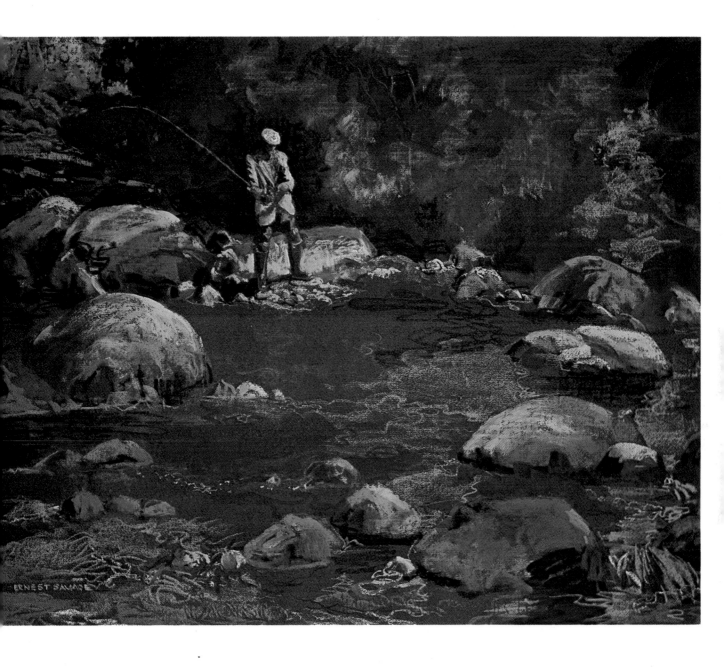

Plate 13. The Salmon Pool, 19″ x 25″, Collection Mr. Alec Spidy. Directors of coronary-causing, pressurized companies like to have an antidote to the stress to which they're subjected in the boardroom. What could be better than a pictorial reminder of a relaxing fishing excursion? This is precisely how this picture came to be commissioned, with the request that the angler be recognizable as the picture's owner! Obviously, the angler had to be the focal point of the picture, but the design called for some natural arrangement of the boulders, as well as a thoughtful assessment of the water flow and the play of reflections. I chose the spot and used a Canson Mi-Teintes No. 501, a very dark brown paper, as the base for the picture.

Plate 14. Farm Buildings, 14″ x 32″. This was a quick pastel study of an interesting group of very ancient farm buildings. I used gray paper and made a vigorous draft of the composition with brush and black India ink. The pasteling that followed was done in the same broad style with less than 15 tints. My aim was to create an impression through simplicity of treatment and broadness of style.

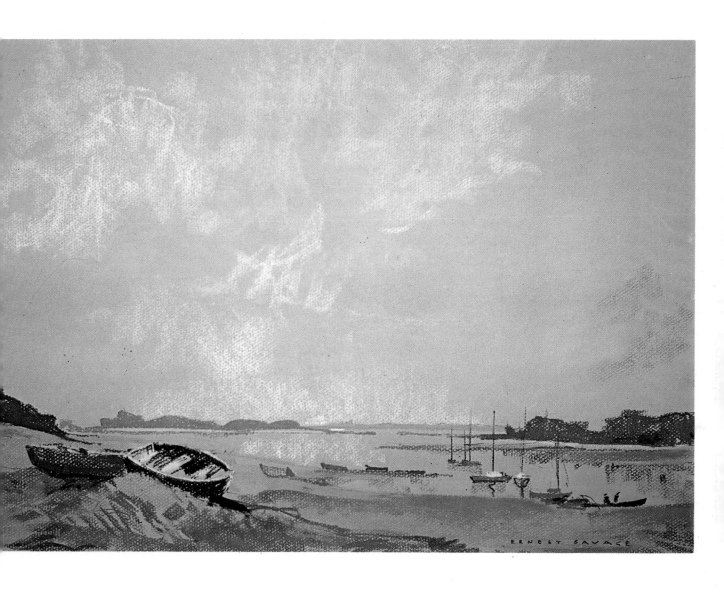

Plate 15. Low Tide, 15″ x 22″. For this subject, I chose an unusually light-toned paper from the Canson Mi-Teintes range called pearl. a light, warm gray, No. 343; four-fifths of it was used for the sky. My aim was to treat the sky in the simplest fashion, and to show its tonal value by the use of the pearly gray paper. Much of the sky's value was reflected by the flat expanse of the estuary, and the bordering marshes and mudbanks. I obtained the depth in the picture by carefully scaling down the values of the tree groups and land masses as they receded into the distance.

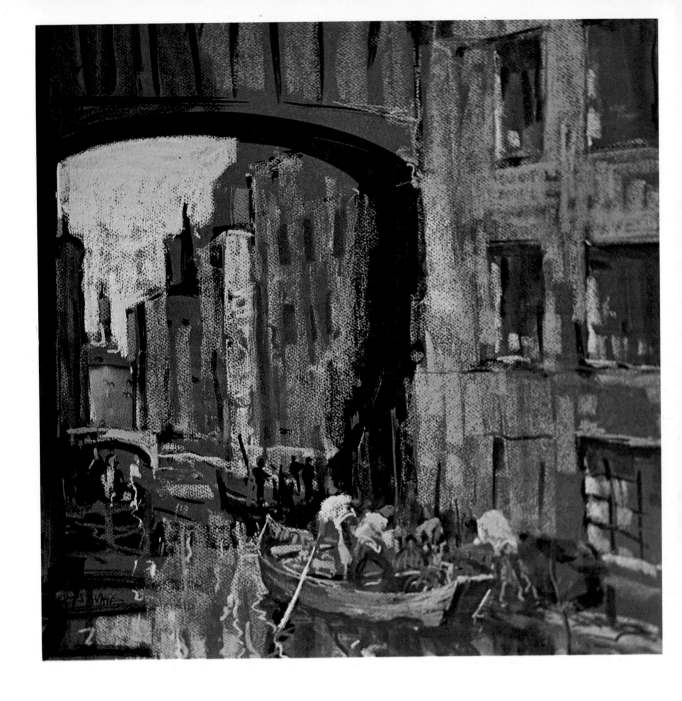

Plate 16. Bridge of Sighs, Venice, 20″ x 24″. I stood poised between easel and a large audience in the Royal Institute Galleries, Piccadilly, London, about to start a carefully prepared pastel demonstration of a landscape study. However, I sensed a lack of interest in it on the part of the audience. So, rather challengingly, I said: "Well, friends what about *you* choosing the location? So long as I've been there, it's yours!" The audience woke up with dozens of suggestions for scenes the world over. Venice seemed to be the most popular. So beaming at an old man in the front row, I asked, "And what part of Venice would you like sir?" He came back like a shot with, "The Bridge of Sighs," and that became the subject of this study. My representation of this famous spot is only a memory impression. Sketching helps to cultivate the memory, and builds up a store of experience in a way that photography does not.

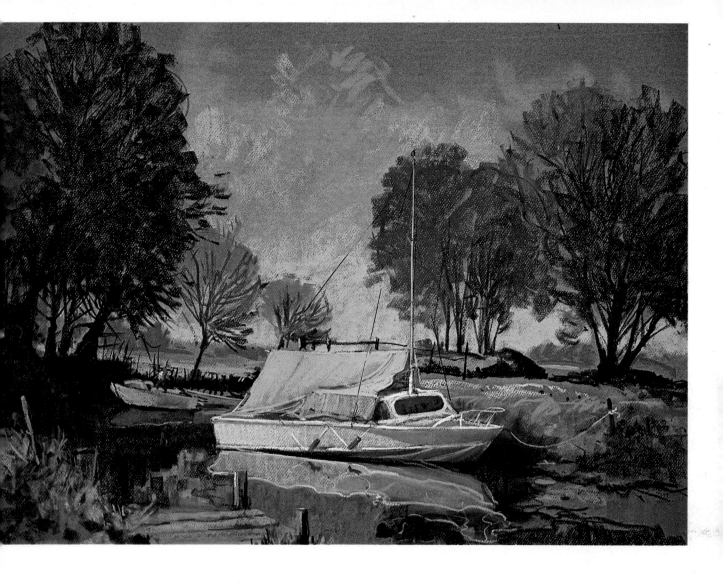

Plate 17. Quiet Backwater, 22″ x 30″, Private collection. It was a hot summer's day when my group gathered round to watch this demonstration. It's not good to work a picture in any medium with the sun shining directly upon it. It makes a judgment of values very difficult. So remember to set up your easel in such a position that your work is shaded, or at least receiving only diagonal rays from the sun. Also avoid working in your own light and throwing shadows on your picture. It isn't always necessary to point your easel at the subject. You're painting, not shooting it! The most interesting part of this scene was the boat and the way it created reflections in the water. Quite obviously, the lights here are reflected darker, and the darks lighter. Midtones, therefore, had to be reflected in the same degree of value.

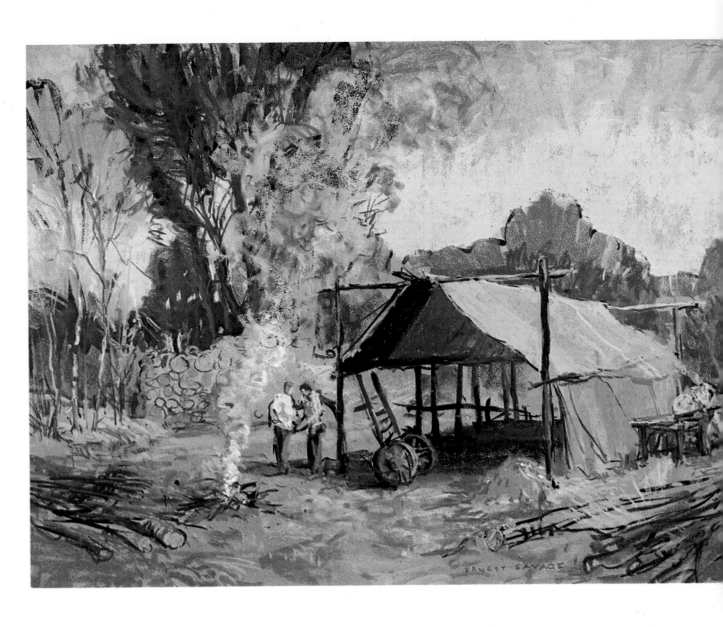

Plate 18. Cleft Fence Makers, 22″ x 30″, Private collection. Here's another of my rural-activity studies. These men travel from thicket to thicket, felling the slender chestnut saplings which they split and wire up into neat rolls of fencing. You can see the result of their labors in the stack behind the smoke of the fire. From a pictorial point of view, it was the contraption of their primitive shelter that interested me. So I went to work on the shelter and the wood smoke against the tree backing, then briefly described the figures.

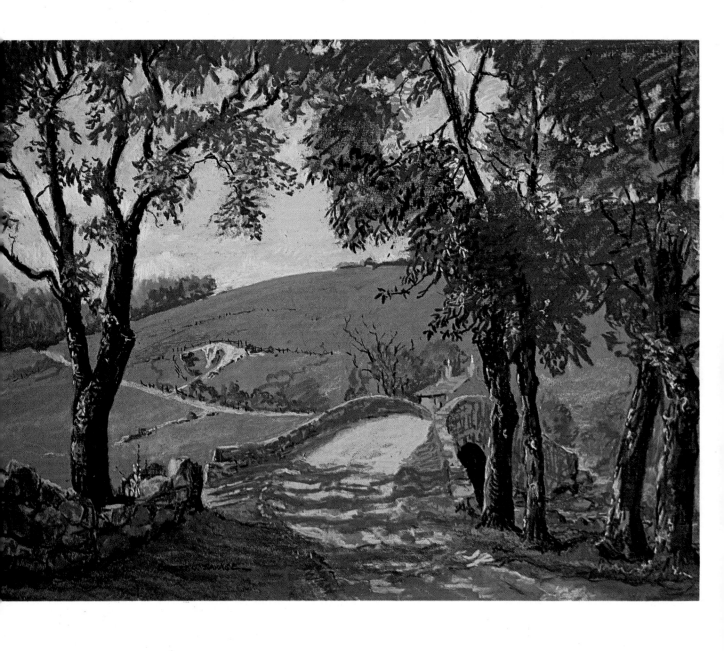

Plate 19. Trees by the Bridge, Collection Mr. Alec Spidy. This fine old pack-horse bridge crosses the higher reaches of the River Dart, on the fringe of Dartmoor. The strong sunlight dappled the track with patches of warm light, and caused the foliage of the trees to shimmer in its rays. These were the effects that attracted me, apart from the unusual viewpoint chosen for the bridge, and the curl of the track as it went over the distant moorland.

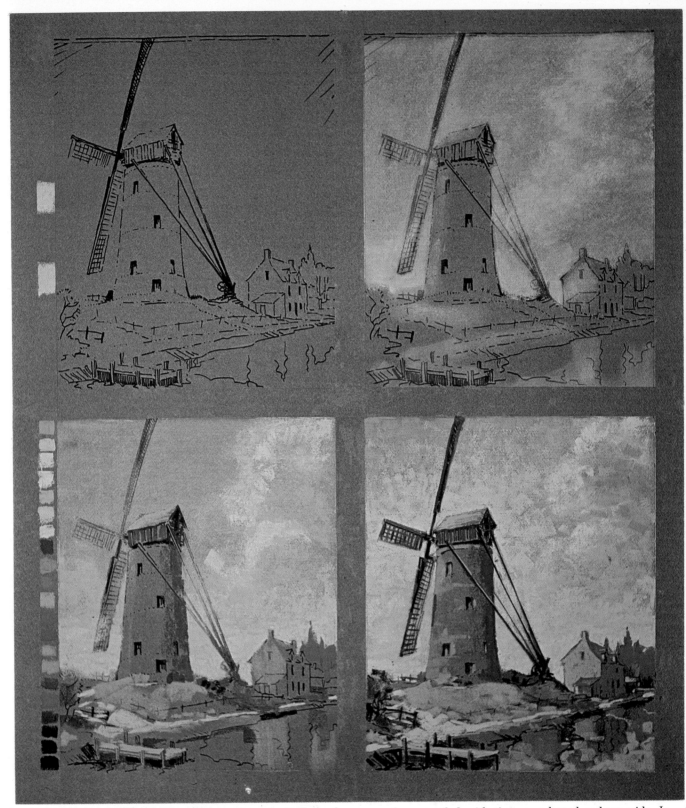

Plate 20. Windmill at Damme. This study made in Holland has been broken down into four stages to show my method. In *Stage 1* (upper left) I made a pen and ink layout and chose the two tones I used to pastel the sky in *Stage 2* (upper right). In *Stage 3* (lower left) I rubbed in the underpainting of the sky and started to define the cloud formation. Next I switched to the darks under the landing stage, the shadowed side of the mill, and its stays. Other light areas below the mill and on the path leading up to it were then pasteled with tints preselected and set aside. In *Stage 4* (lower right) the sky was completed by using the seven tints at the top of the color key to give a gradated effect that darkened in the upper reaches. I carefully judged the relative values of the buildings and their reflections, and contrived not to overwork this area. For simplicity, I disregarded the fence below the mill. Finally, I added accents to the light and dark areas. (The 21 pastel tints used for this sketch are shown beside the sketch at the lower left.)

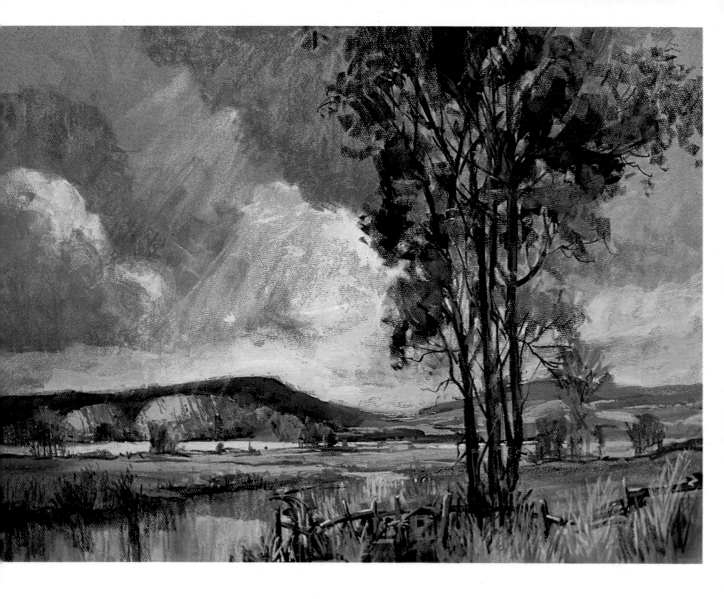

Plate 21. Amberley, Sussex, 22″ x 30″. This is the final stage of the sketch shown in Figure 14. I pasteled the sky with suitable tints and tones to render it dramatic and stormy. A purpel-gray pastel was swept across the opaque black ink of the distant hills, while the fields on them were indicated with subdued gray-greens and browns. The streak of sunlight in the middle distance was appropriately described with a pale yellow ochre, whose tone I varied for the lit portions of the quarries. Now I tackled the foreground trees, the fencing, and the reeds, which I delineated loosely, using olive greens at various depths of tone, and browns and grays. The reedy bank of the river needed a more positive green, while umber was needed at the base of the reeds where they shadowed the mud banks. Then I dealt with the reflections, using vertical strokes of a tonal value slightly darker than the light parts of the sky and letting some of the water surface be represented by untouched gray paper. Finally I placed a few very bright green touches to the reeds on the nearer bank at the foot of the picture, to serve as something of an eye catcher; but I subordinated these to the streak of sunshine that was intended as the center of interest.

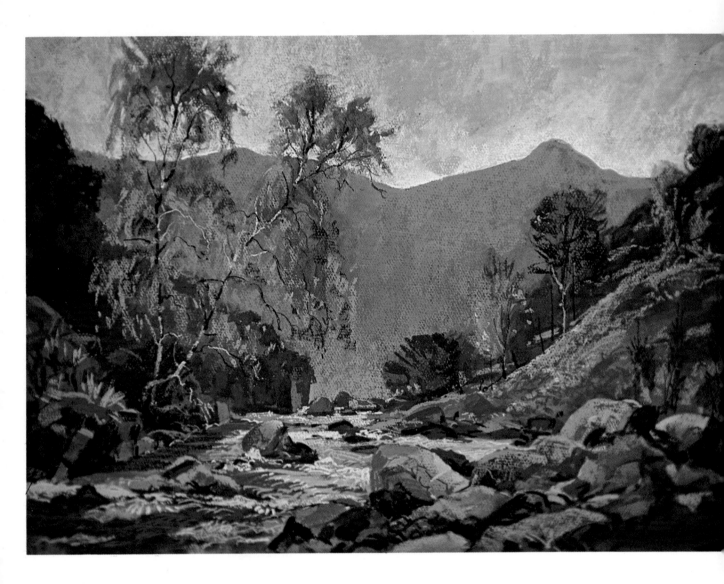

Plate 22. Mountain Stream, Scotland. In making this picture my sketching easel was jammed into rock fissures, and I perched precariously on a boulder. In view of the obvious approach of heavy rain, I selected only a half (15" x 22") of a blue-gray Canson Mi-Teintes paper. I made a layout with several brown and gray Carbo-Othello pastel pencils. I decided to maintain the effect of grayness to typify the weather conditions and to capture the cold austerity of the scene. Leaving the gray paper to take care of the main mountain mass, I first briefly described with pastel the tone of the sky above them. Then I turned my attention to the turbulent water, using lights and darks with strokes that suggested the direction of flow as it gushed around isolated rocks. Notice my use of strong dark behind the silver birch trees; this was to enhance the feathery lightness of their foliage. Bright greens were used for ferns growing out of rock cracks. The rocks on the right bank were done by using pink and gray pastels with a drag stroke to indicate the texture.

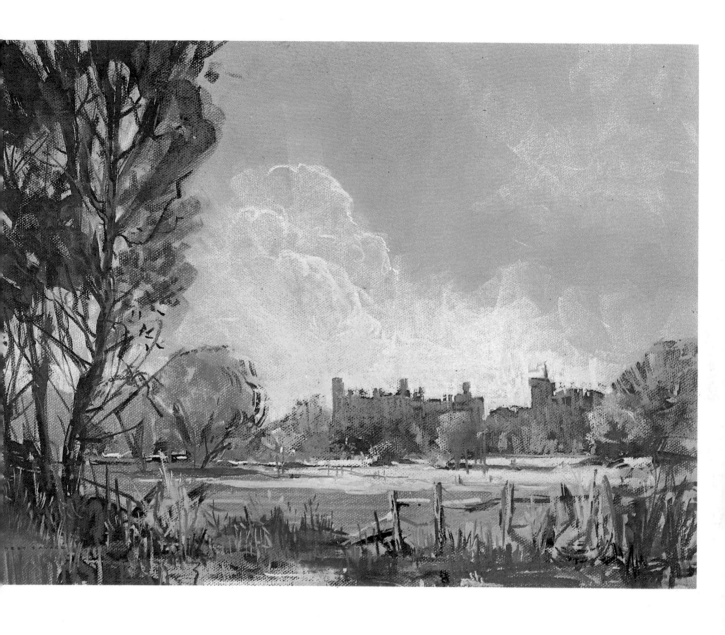

Plate 23. Arundel, 22″ x 30″, Private collection. This is the black and white illustration in Figure 25 in color. You may find it helpful to compare the two illustrations, because you can study the tonal values of the same picture in black and white and in color. This painting was an attempt to capture a very fleeting effect: the part of the landscape which was receiving strong rays of sunlight. I chose a steel gray paper to provide the general tone of the sky so that I could dramatically describe the breaks in the heavy rainclouds that were lit by the sun.

Plate 24. Flooding in the Fall, 15″ x 22″. Pitman collection. I used a coldpressed watercolor paper, and loosely painted a watercolor backing to provide an approximation of the tint and tone of the landscape. Normally you'll work on paper that's already tinted in one tone throughout. With this method you can, in a sense, make your own tinted backing for the pastel, and adjust the tint and tone to suit your needs. I selected this method to capture the effect of sunlight over the flooded fields. Although the paper surface was eventually covered with pastel, the watercolor paper prevented the pastel from getting in the little holes of the surface texture. The watercolor deposited there gleamed through the pastel adding sparkles of light.

Plate 25. Sunday Morning Anglers. The final stage of Demonstration 1, reproduced in black and white on page 126.

Plate 26. The Sentinel of the Loch. The final stage of Demonstration 2, reproduced in black and white on page 131.

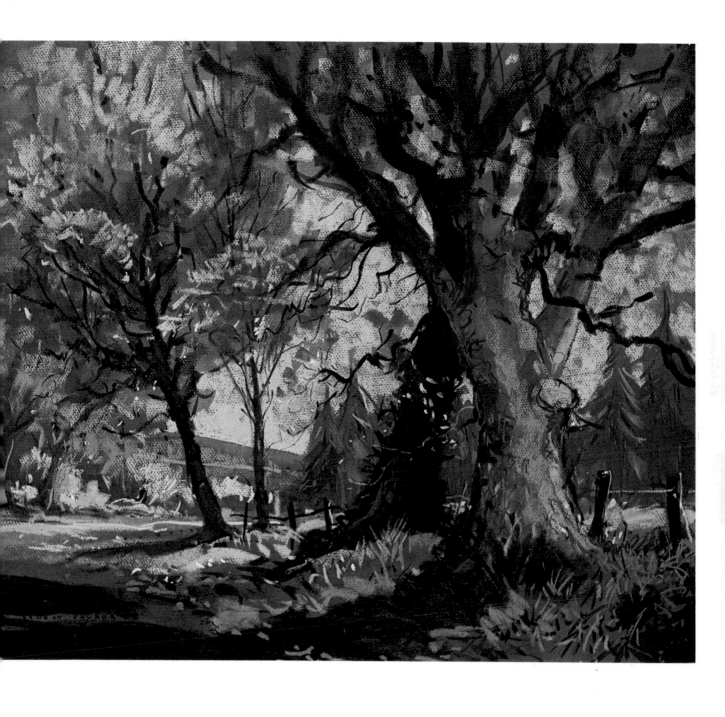

Plate 27. Trees in the Fall. The final stage of Demonstration 3, reproduced in black and white on page 137.

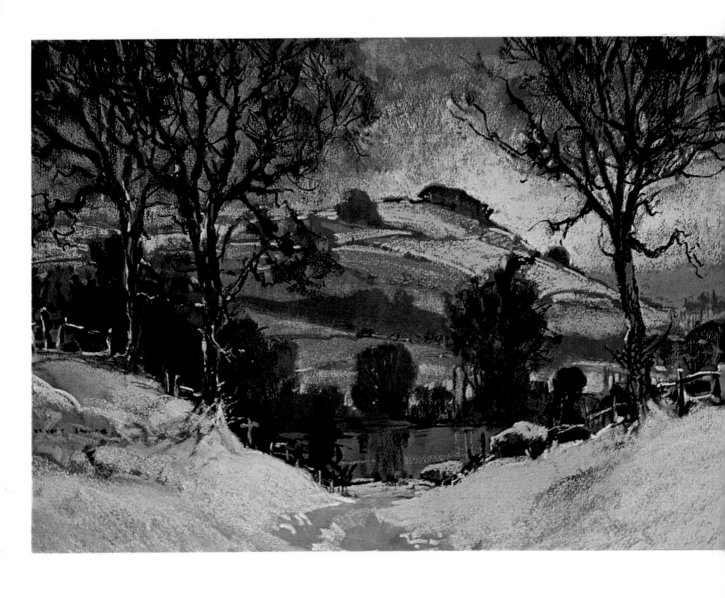

Plate 28. Winter Landscape. The final stage of Demonstration 4, reproduced in black and white on page 140.

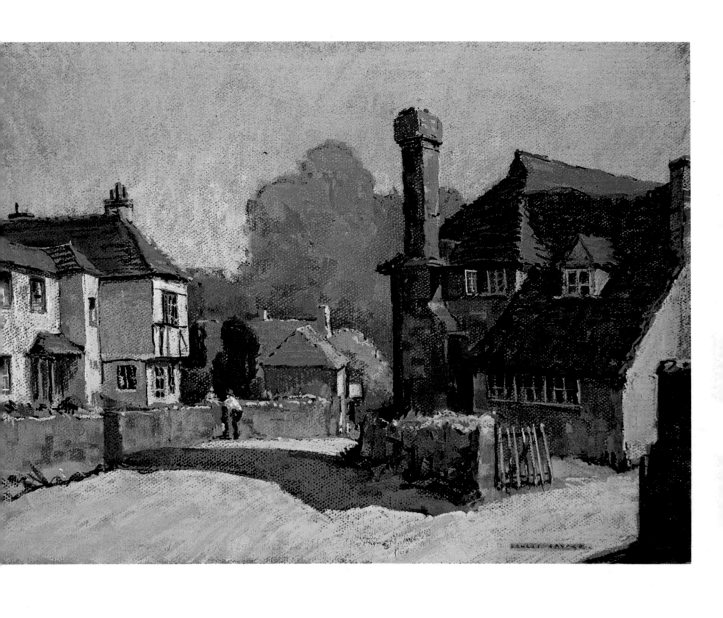

Plate 29. Fittleworth. The final stage of Demonstration 5, reproduced in black and white on page 145.

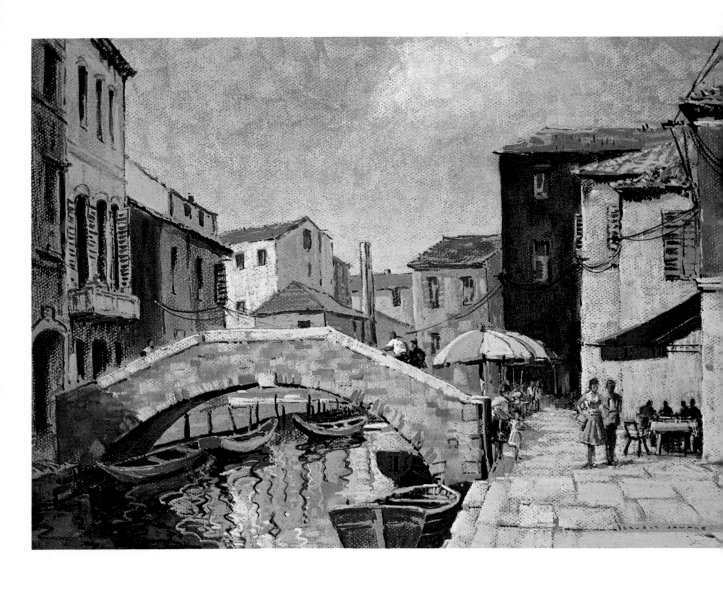

Plate 30. Café by the Bridge, Burano. The final stage of
Demonstration 6, reproduced in black and white on page
150.

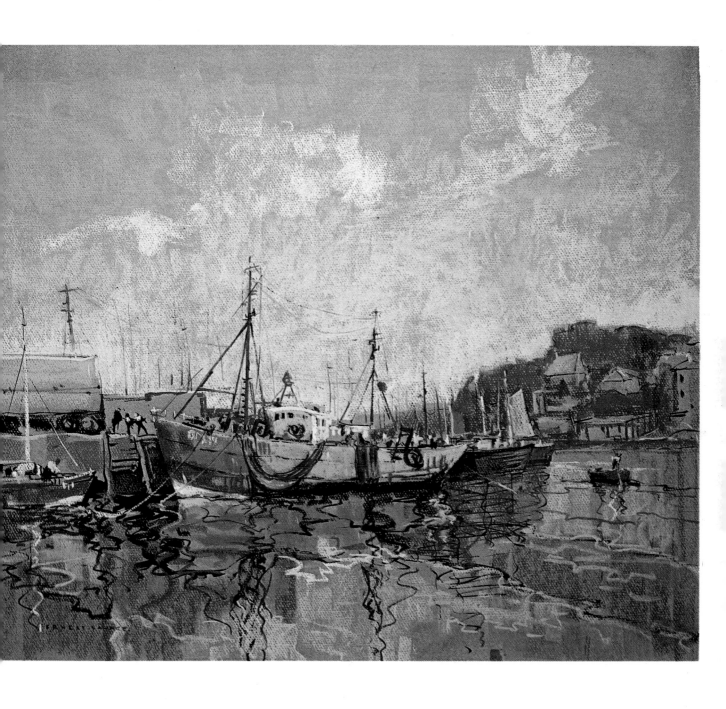

Plate 31. Brixham Harbor. The final stage of Demonstration 7, reproduced in black and white on page 155.

Plate 32. The Old Forge, Wembury. The final stage of Demonstration 8, reproduced in black and white on page 160.

Pictorial unity of sky and earth

Finally, there must be a pictorial unity of sky and earth, for each can affect the other. The light of the sky, pervading the landscape, covers it at times with a tracery of cloud shadows. In like manner, the local color of the fields can reflect upon, and give color to, the bottom parts of the clouds. Thus, something of the color of the land can be found in the sky, and vice versa. Even if you're not sure that you can actually see this phenomenon, you should assume it's there and purposefully unify the color elements of your picture. Do this by gently applying to the sky a tint that you feel is needed to balance the color of your picture.

Pastel techniques for skies

I'm frequently asked what the technical finish for a sky in pastel should be. Some want to rub a lot of pastel into the paper to achieve a so-called "softness" for the clouds because they dislike "those little spots of paper color" showing through them. My usual reply is, "Well, it's your painting. You're in charge, and you're free to do what you like." Without question, the serious painter must, in the end, express himself in his own way, according to his preferences and inclinations. These may lean toward a strictly formal and representational approach, or toward something of an impressionistic nature that fulfills an emotional need for a more personal type of visual expression. Sincerity of motivation will be the yardstick by which final judgment is measured.

Lofty thoughts, however, offer you little consolation if you're a struggling novice. For that reason I recommend that to achieve the result you want in the simplest way, take care not to overwork a sky. Above all, use one technique throughout a picture. Don't, for example, work the sky up with the loving caresses of a cotton pad and depict everything else in the picture with pastel strokes of crisp nonchalance. It's not that I'm scornful of rubbed-in pastel. You can obtain many lovely effects, especially of morning and evening skies, by gently using your fingertip or a cotton pad to blend pastel tints on your paper for an underpainting. Afterwards, you can make more direct strokes on this prepared ground to force up the light or to model cloud formations.

Most of the coming demonstrations will explain how I tackle various sky effects. In my first, *Sunday Morning Anglers*, I'll deal in detail with the sky and distance only, emphasizing a direct way to pastel them.

Demonstrations

DEMONSTRATION 1:

Sky Study

The water-lily-covered surface of my local fishpond, backed by the low hills, provided a good setting for the sky study, *Sunday Morning Anglers*. The land area occupies about a third of the paper, leaving two-thirds sky. The paper I used was a very pale gray Canson Mi-Teintes called moonstone, No. 426. As you undoubtedly realize, I chose this light paper to more or less represent the tone value of the sky itself. Except for a horizontal pencil line that indicated the approximate water level, there was no layout.

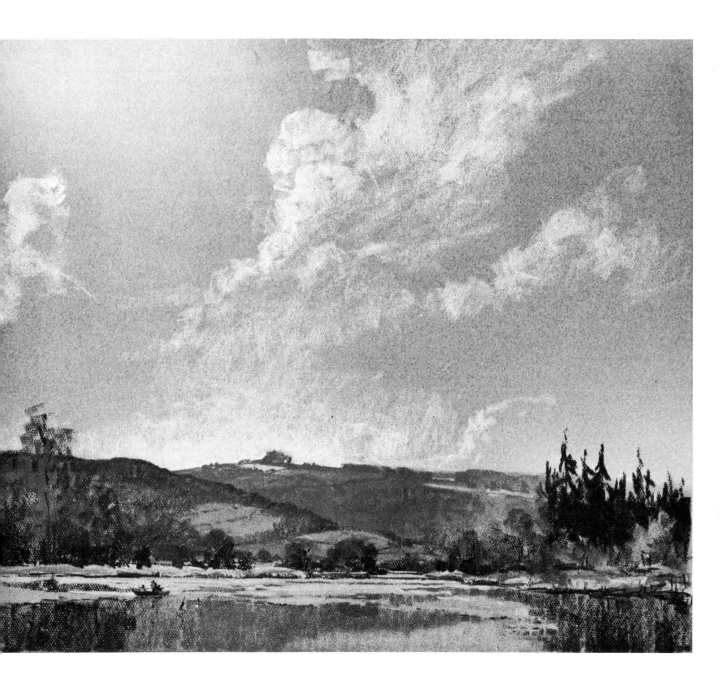

Sunday Morning Anglers (Stage 1). I blocked in the area occupied by the distant hills with a darkish blue-gray pastel, used on its side. Then I rubbed the pastel into the grain of the paper with a pad of absorbent cotton to darken the light paper where the main dark tone value in the landscape occurs. Over the area where the pastel is already rubbed in, I described the contours of the hills as simply as possible with several grayed colors of deepish tones. I set the cloud composition with the palest lemon yellow, sensitively altering the pressure of the pastel to depict the light and shade in the cloud formation. For the spread of pink color at the horizon, I pressed the appropriate pastel firmly into the horizon contour to obtain its very lightest value. Above this, I blended a very pale gray into the pink, following with the palest of green-blues that reaches up to the clouds. Then I returned to the tree-lined shores of the pond, pasteling these broadly and introducing the marginal banks of reeds. Next I began to describe the flat stretches of water-lily pads and, with vertical strokes, to give some indication of the reflections of the hills and trees.

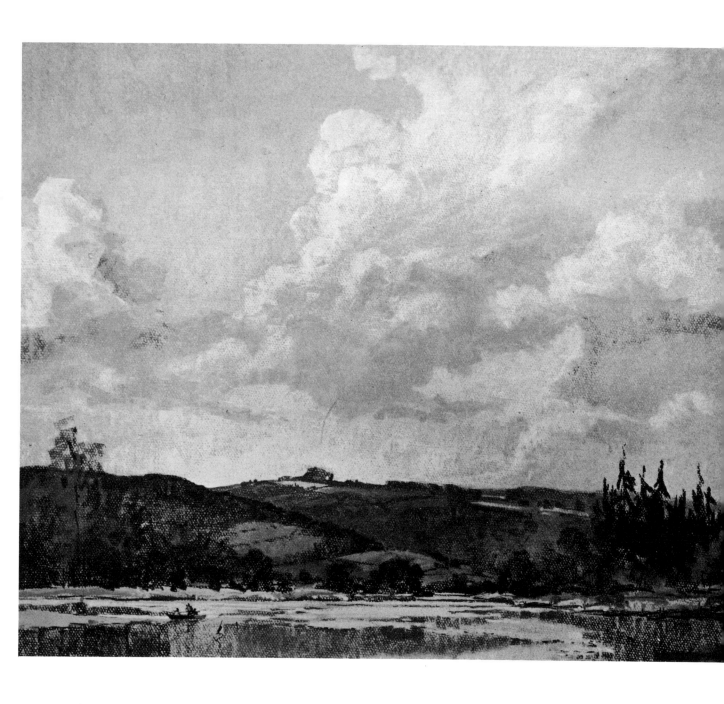

Sunday Morning Anglers (Stage 2). The clouds were rapidly breaking up, leaving patches of blue sky that got paler and slightly green as they receded into the distance. I started to record this change in tone by working with a preselected series of six blue pastels. I used the darkest of the pastels for the upper region of the sky and gradually interblended the others until the distant blue patches were put in. Two tone values of pale mouse-gray were used to represent the cloud shadows; the darker of the two was used for the cloud bases. I used pressure to effect a change in tone, so that it appears that the darkest areas of the cloud shadows are in those parts of the clouds that are nearest the eye. This, in turn, gives the impression that the clouds are receding. I then added some pale, lilac gray to the pink at the horizon to model the distant cloud formations there and to add brilliance. In all, I used about 16 tints for the sky, and at no stage did I do any rubbing at all. For the final stage in color, see Plate 25 in the color section.

Mountains,Water and Rocks

Although the highlands of Scotland don't rank among the world's highest mountains, this historic touring area has a rich, rugged natural beauty. It's a favorite painting location for me, and I run summer schools there almost every year.

Scotland's noble mountains, rock-strewn rivers, and deep, cold lakes (that the Scots call lochs) are magnificent subjects for the painter. The whole countryside is dotted with ancestral castles. Many of them are still inhabited, and full of priceless art treasures. Plaques are everywhere, commemorating bygone battles fought by the Scots and the English, and even more often, among the Scots themselves. Centuries ago there was a fearful rivalry between the Scottish clans; for reasons of security, the chieftains of the clans built the castle fortresses that were their homes in the most strategic locations.

One such is Eilean Donan Castle on Loch Duich, in the western Highlands. This has been the stronghold of the Clan Macrae since the fourteenth century, and the present clan chieftain still resides there. The castle, perched on a rocky spur that projects from the shore of the loch, looks like a fabulous film set. For over five hundred years until the eighteenth century, it withstood many famous sieges and bloodthirsty raids; then it was almost totally destroyed by shells from English frigates that had been sent to put down the Jacobite rebellion. I hope you feel the same thrill of excitement that I do as we approach the castle causeway for a closer look at *The Sentinel of the Loch*, which is your next demonstration.

The Sentinel of the Loch (Stage 1). As you'll see from my sketch notes (*Figure* 56) of other views of the castle, I had difficulty in making up my mind about which of the many attractive alternative compositions to choose. For the purpose of this demonstration, however, we're going for the closer look, so that I can explain how I went about portraying the rocks in the foreground. I think you'll agree that the grim fortress calls for a gray paper; that's why I selected smoke gray Strathmore charcoal paper. I made the first draft with two hard gray pastels, one lighter, and the other darker, than the paper. Using pastels in two tones for a layout such as this enables you to come to terms with the overall values in the work and makes the subsequent choice of pastel tints somewhat easier. I decided that some of the vigorous lines describing the rocky formation in this draft would remain visible in the final stage.

The Sentinel of the Loch (Stage 2). My first aim was to give
some credibility to the recording of good tone values,
insofar as they concerned the light of the sky compared
with the dark of the mountain mass and the castle sil-
houette. I began by interpreting the scudding, broken
clouds. Do you see how these form a pattern of light in
converse direction to the mountain outline and the bridge
top? The very lightest cool gray pastel was then pressed
into the horizon. The sky was made to seem that it ex-
tended upwards by using a slightly darker gray, together
with some pinkish tints for the scurrying clouds. To add to
this illusion. I left the upper reaches of the sky untouched.
I turned to the dark mountain mass. Here, using dark
purple and steel-blue grays, I manipulated the pastel at
at varying pressures to describe briefly the mountain's form. I
used a slightly warmer dark gray to begin the shadowed
areas of the castle. To indicate something of the dark in the
rocks, sepia and burnt and raw umber of deep tones were
employed. The narrow slip of light in the distant water was
carefully placed with the second lightest gray, rather than
the very lightest gray that was used for the sky.

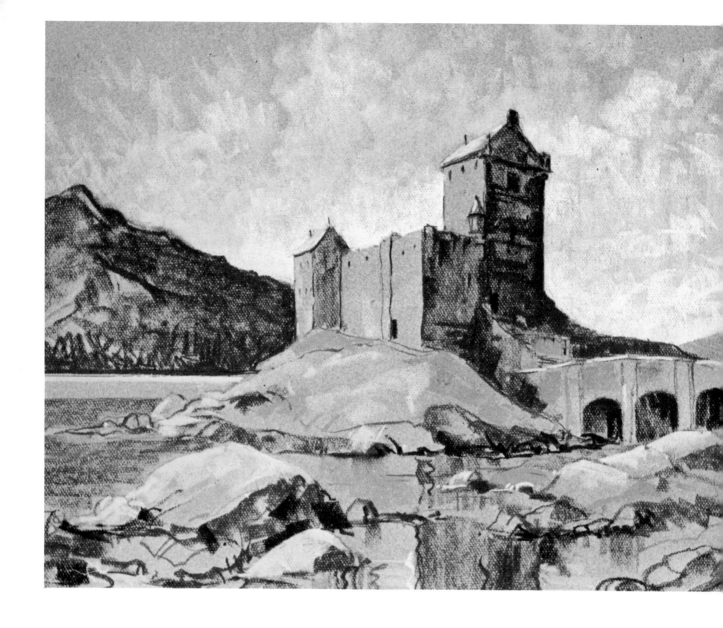

The Sentinel of the Loch (Stage 3). I now proceeded to execute the medium tonal values with pastels in tones that were slightly lighter or darker than the tint of the paper, I described the grass-covered rock at the castle base with quiet greens. Then, taking care to show their strata formation, I treated the weather-stained rocks with their local color, pasteling with fawns derived from pale Vandyke brown, burnt sienna, and olive green. While doing this, I watched the value of the rock reflections in the water, and chose appropriate pastels to begin the effect of these, as well as the castle reflections. (I always make it a point to give close attention to reflections when I'm working on the object that is being reflected. This helps me achieve a better unity of both.) Next, I concentrated on imparting a true tone to the water to the left of the castle, and then to the water to the immediate right. I strengthened the darks of the arches underneath the causeway bridge with neutral grays.

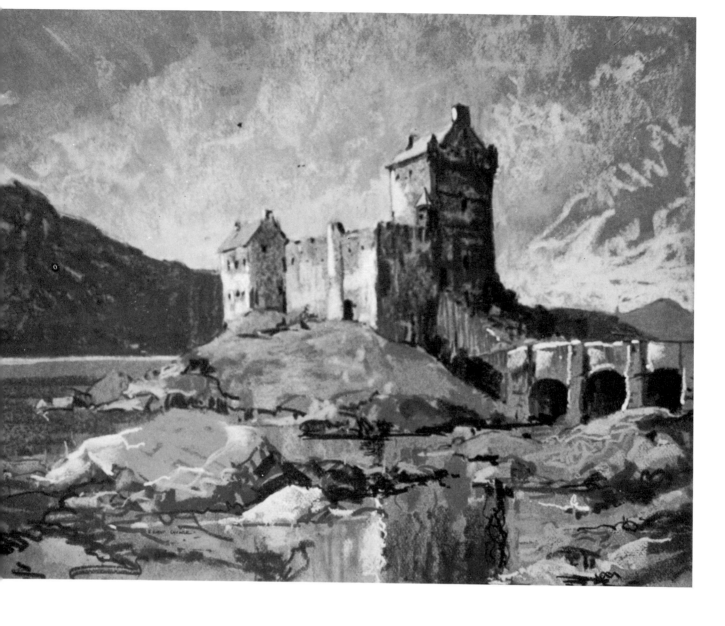

The Sentinel of the Loch (Stage 4). Looking at the work so far, I was more or less satisfied with the broad technique displayed. But it seemed that the castle and the battlements of the bridge needed more emphasis. A quality of light on the stonework, and a few more touches on the architectural features—the turrets, slit windows, and so on—supplied this emphasis. Creams and fawns were used for the light accents, and a variety of grays for the dark, and I was careful to understate the additional work rather than overwork it with too many details. As you see, both the bright and the dark accents bring more life and excitement to the scene. Also, the very limited use of the brilliant green pastels with which I embellished the edge of the grass mound to the right helps to draw the eye toward the shadowed castle entrance. For the final stage in color, see Plate 26 in the color section.

DEMONSTRATION 3:

Trees and Woodlands

Trees and woods have infinite variety and make excellent subjects for pastel, no matter what the season. But fall through to spring, trees are at their best for painting. If you take another look at the illustrations in this book, you'll see many examples of my own treatment for trees. I tend to follow their growth with pastel strokes, which give a better description of their form. The pastel is used on its side for the hazy edges of the twig-tipped branches forming the tree's profile, with the strokes moving from the outward edge of the profile toward the center of the growth. I use the top of the pastel for boughs and branches, and at all times vary the overall colors in these as well as the trunks. I'm sure you've often seen tree paintings in which one color only has been used throughout the entire tree structure. This, quite apart from being unnatural, is monotonous, especially for trees in foreground areas.

Trees are graceful things; so if you include a complete tree in any of your pictures, take care not to exaggerate the girth of its trunk. If a tree is malformed, maimed, or otherwise altered, then, and only then, can some exaggeration in its drawing be helpful. Also, you'll recall what I said earlier about striving for authenticity in your portrayal of clouds. The same holds true for trees. Get to know the characteristics of the various trees so that you can reproduce them faithfully in your work.

I've chosen a fall study for the next demonstration, since I know it's a popular subject and therefore likely to help a good many people. Let's take a look, then, at *Trees in the Fall*.

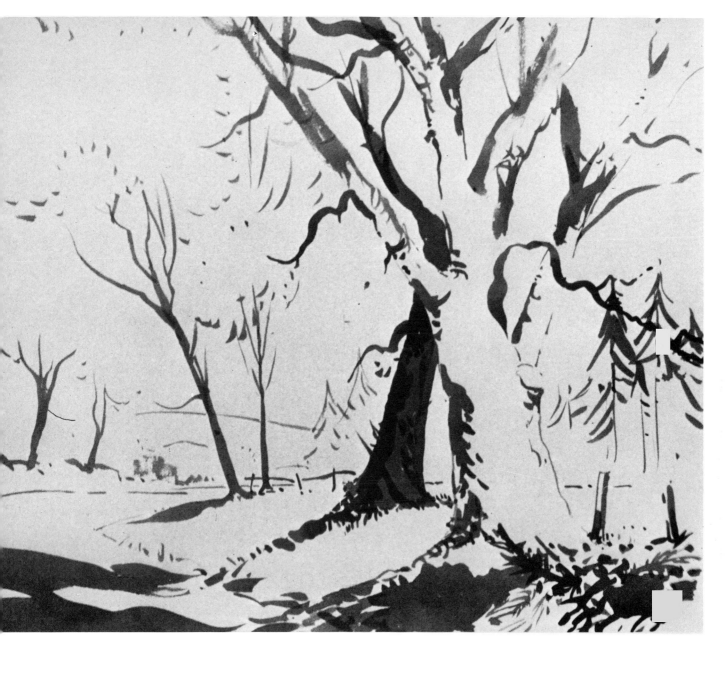

Trees in the Fall (Stage 1). Before settling on its final composition, I made a number of trial sketches for this picture. I was intrigued by the contrast that the light oak tree made against the dark one behind it, to the right. For my final layout, I changed the actual position of the tree so that it became almost vertical, and I placed it farther back into the distance. I also decided that I preferred a squarer shape. The paper here was an amber Canson Mi-Teintes, No. 504. You can't go wrong with this amber-colored paper for a fall study. And a brush-line draft with brown waterproof ink seemed the very thing to go with it.

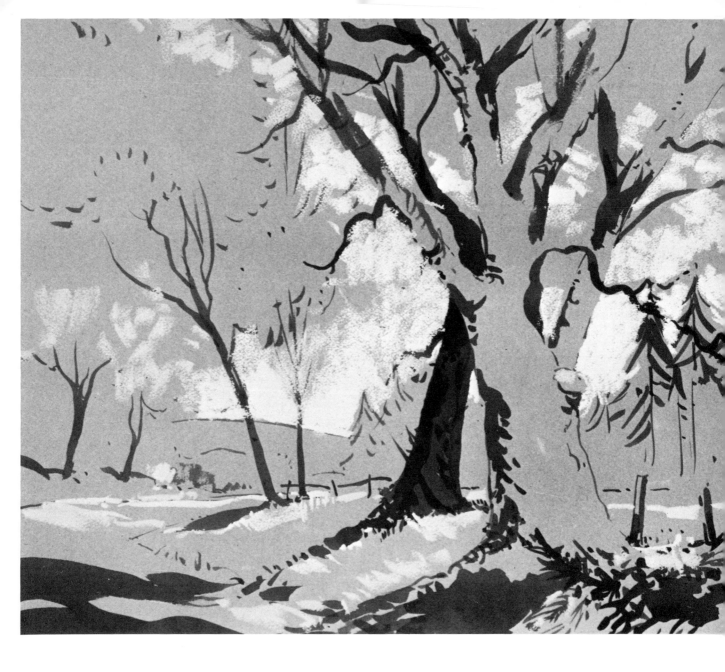

Trees in the Fall (Stage 2). I selected five tints for the sky and then I set to work with the first two of these tints, pressing the lightest one into the sky above the distant hills and easing the pressure when I approached the foliage areas. I then made broad use of the side of the second pastel to represent those parts of the sky that could be seen through the branches of the trees. Finally, I chose pastels from the lightest tints to make firm strokes that graphically describe the lights on the road and elsewhere in the middle distance. I started with light pastels because I wanted to set up the tone values, for in Stage 1 we already had the mid-tone brown of the paper and the dark tone of the brown ink. To see the effect this produces, squint at it through your lashes.

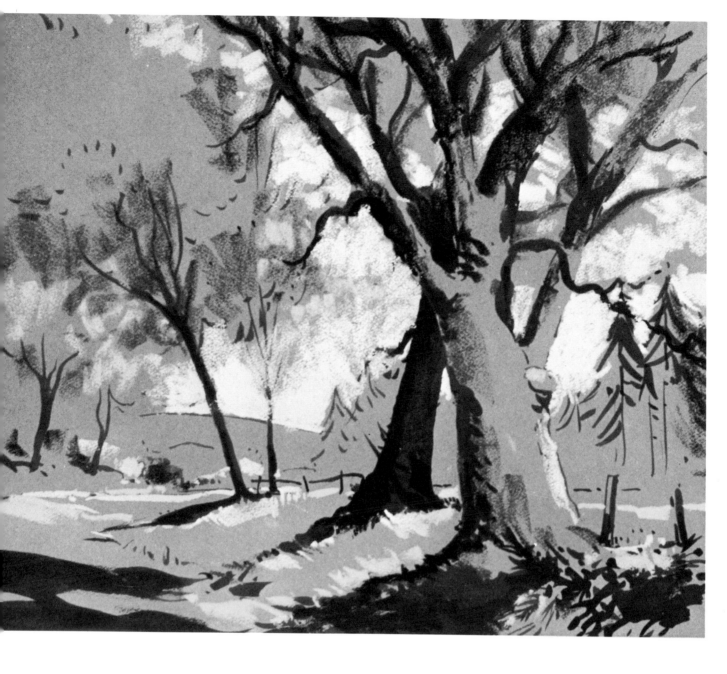

Trees in the Fall (Stage 3). Having brought up the light in Stage 2, I returned to the darker values, using the four pastels. The first two are purple-grays of differing strengths; the third is a dark green-gray; and the last, a rich sepia. Starting with the lighter of the two purple-grays, I indicated the darkness of the thick boughs in the upper region of the trees with broad treatment on the side of about a 1″ piece of pastel. I did this to give force to the amount of dark that there would be in that region because of the huge umbrella of branch tracery and leaves above it that cast a great deal of shade. Next, to kill the brownness of the ink work, I loosely covered the tree shadows on the foreground road with the lighter of the purple-grays. Then I began to develop the tree trunks and the cast shadows of the two trees immediately in front of the distant hills. All these various areas of color got the picture going as a whole, for now all parts of it could be compared for tone value.

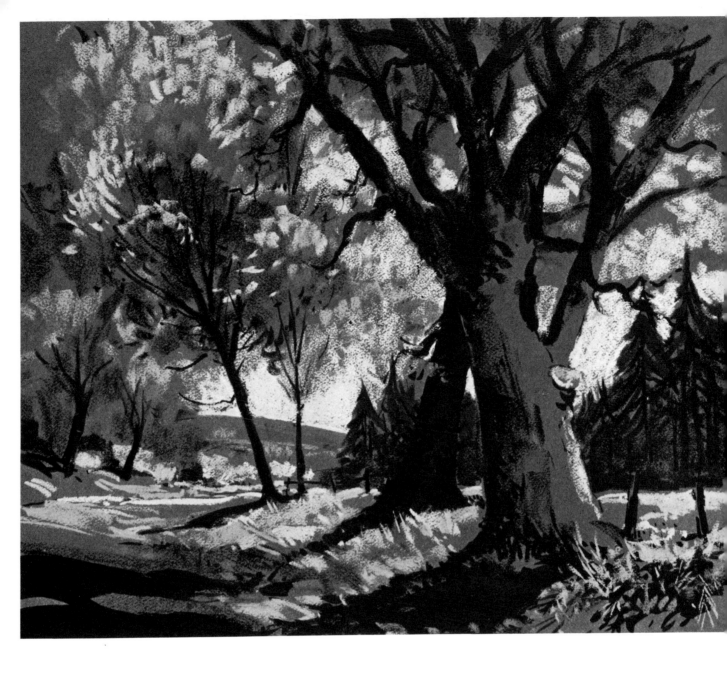

Trees in the Fall (Stage 4). The distance and middle distance now needed attention. With three pastels—two gray-greens and a lighter purple-gray—I started to work on the mid-distant group of conifers, describing their spiky characteristics by strokes made with the edge of the pastel; I used the purplish tint toward their bases. When these were done, the distant hills could be judged for tone, and I described their contours with a cold gray. A streak of pale viridian delineated the field of winter corn stretching in the distance behind the trees.

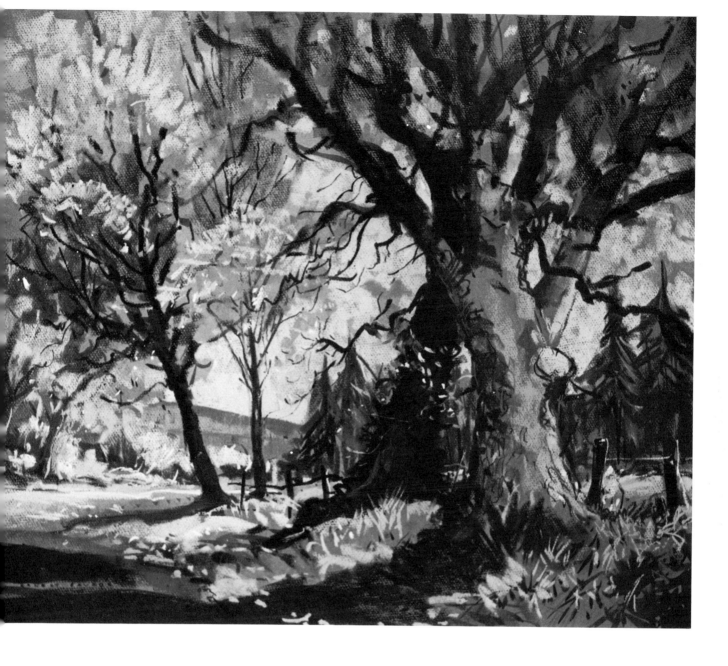

Trees in the Fall (Stage 5). I now set to work on the middle values as seen in the dying coarse ferns (bracken), and the roadside weeds and twigs; then I finished with the bright glow of green from the field behind the two main trees. Broad strokes were used throughout, especially when dealing with the strikingly colorful mass of autumn foliage to the right. I built up the darks of this foliage with strokes at half pressure, for I intended to go back over this area with more firmly applied additional strokes for the sunlit foliage. Throughout the process, I made sure not to lose the glow of the amber-colored paper which, in places, was left entirely untouched by pastel. The nearest tree was now finished with the variegated tints and tones of the bark, and other details. All that remained to be done now were the color accents. To reinforce the fall brilliance, I introduced little spots of very bright color—vivid orange, purple, and pale lemon. For the final stage in color, see Plate 27 in the color section.

The Winter Landscape

Much of the success of your winter pictures will depend on how well you judge the tone values of the snow. Appearances can be very deceiving, but you can take it from me that the whiteness of the snow at your feet cannot possibly be the same as that lying half a smile or more away. Distant snow will be grayer, or will tend toward blue or violet. Even the shadowed areas in foreground snow will vary according to the light prevailing at the time, which will determine whether they are cool, that is, bluish; or warm, that is, inclined toward a purple-brown. The use of a stark white to represent snow can look very forced and artificial; so you'll need a good selection of pastels to obtain the subtlety required.

Your final choice of paper will be a great importance in the pasteling of winter scenes. Pale blue and gray tints are obvious choices, though you could make very effective studies on a very pale, cold pink or even a blue-green backing. The first consideration in your choice of paper should be the proportional amount of light or dark values in the picture. If you're planning to use mostly dark values with an occasional flash of fresh snow, a darker-toned paper would be the best to use.

Using white paper for direct pasteling is going about things the hard way, but I've occasionally used white paper for winter scenes. Therefore let me explain how I went about doing the picture, *Winter Landscape*, using a Strathmore heavy-weight, mold-made, white watercolor paper. On this I painted a gouache backing calculated to give me the general variation of values and to make easier and quicker work of the final pasteling.

Winter Landscape (Stage 1). I laid down a simple charcoal draft for this composition on the white watercolor paper and squeezed dollops of designers' gouache around the edge of a large white plastic dish. The colors were ultramarine, light red, alizarin crimson, yellow ochre, viridian, and white. Using plenty of water, I mixed a blue-gray wash of middle tone with the blue and light red, and passed it directly over the top two inches of the picture. While this was still wet, I painted a wash of yellow ochre into it that extended down to the hilltop. Then I went back to the original blue-gray mixture for the distant hill and the lake area, and carried it down to the hedgerow. The light snow begins here, so using only clean water, I brought the wash down to the bottom of the picture. Now, without delay and while everything was still wet, I dropped in a darker gray to describe the contour of the distant hill and the fields; this same gray was also dropped into the tops of the trees to capture the misty softness on their edges. I then made other darks, using a mixture of crimson and viridian, and used these stronger values for the treetops and bushes above the snow. When all was dry, a little more detail was added to the tree branch and trunk, and to the fence, to provide an even stronger contrast to the light of the snow and to give the composition a dramatic quality.

Winter Landscape (Stage 2). I started pasteling with a very yellow ochre to place the flash of light in the sky above the hill, and worked this in and out of the areas between the branches. Above this, I used purple and blue-grays to extend the sky that backs the three foreground trees. Then I picked out the fields on the distant hill with direct strokes of pale blue-grays and bluish violets, adding darker accents for the hedgerows and trees. Next, I worked on the mid-distant trees with deep-toned brown and purple-gray pastels in order to get the degree of dark that would force up the light of the snow. The reflections of these trees in the frozen lake provided interest around the focal point. The three main trees were modeled with a variety of grays, gray-greens, and so on, of a strength that would make them stand out against the sky. Later I indicated the snow lodging in their branches. Since there's so much detail in the upper regions of the picture, the final touches, which consisted of the snow of the immediate foreground, had to be rendered in a simple fashion and kept tranquil. Therefore, I broadly pasteled the play of light on the banks where shadows from the initial wash were showing through. For final stage in color, see Plate 28 in the color section.

Old Buildings in Landscape

My studio is situated on the outskirts of a picturesque English village called Fittleworth, which has been an artists' haunt for a very long time. Turner and Wylie sketched its medieval cottages and farm buildings, many of which still exist today. So, in spirit, we're going to be in good company as we carry our sketching gear over a fifteenth-century humpbacked bridge and up to where a group of Tudor cottages straddle the main road.

It may interest you to know that a month or so before I sketched this scene, workmen, who were doing some restoration on the building at the left, discovered beneath layers of plaster in the upper room overhanging the bay window a genuine Tudor wall painting. Specialists quickly arrived and carefully removed the painting in pieces of a square foot each. They intend to reconstruct the old painting in a full-scale medieval village which is being developed as a museum project at Midhurst, a few miles away.

Aside from the historic interest of these buildings, and the problems involved in treating them with pastel in a broad technique, I chose this spot for my demonstration because I wanted to show you how I go about capturing the effect of morning sunshine that gives more brilliance to the white- and-cream-washed cottage buildings than it does to the sky behind them. Squint at *Fittleworth* and you'll see for yourself that the sky is not so high in tone value as these ancient, half-timbered walls.

So let's settle down on a tall, grass-covered mound, conveniently started for us many generations ago with trash from the blacksmith's shop opposite; from this elevated spot, we can survey our delightful subject.

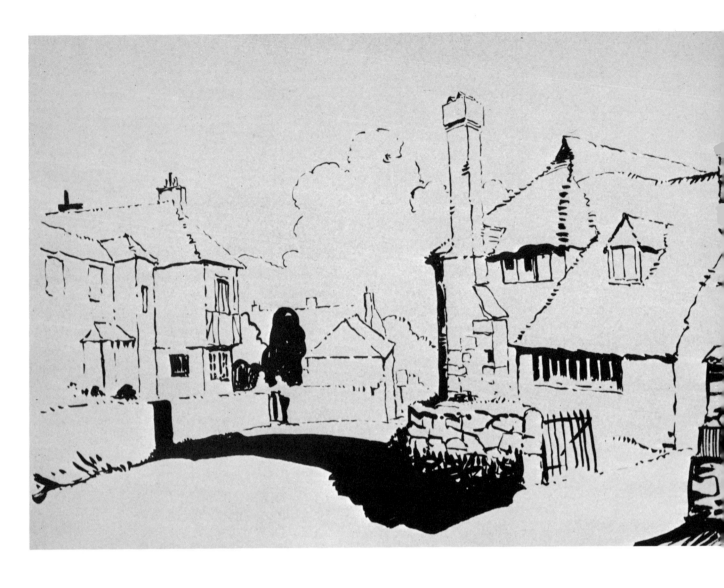

Fittleworth (Stage 1). This was one of those rare occasions when the subject composed itself naturally. My center of interest was the tall stone-and-brick chimney that rises majestically above the roof of old clay tiles. I was especially intrigued by the strong shadow that the chimney cast, which followed the irregular curvature of the road, traveled over the grass verge, and then went up and over the old stone wall. It thus described the form and texture of the places over which it passed. I chose Canson Mi-Teintes gray, No. 431 as my paper and began my brush drawing in black India ink. I worked on the chimney and completed its interestingly shaped shadow before doing anything else. Notice how I exaggerated the darks in the drawing and always depicted the tops of the sunlit roofs with a broken line. Notice, too, how I used the dark of the coniferous bush in front of the cottage on the left to describe the shapes of the two figures standing in the sun by the gate, having an informal chat. It's a good idea to look for this kind of contrast in your sketches.

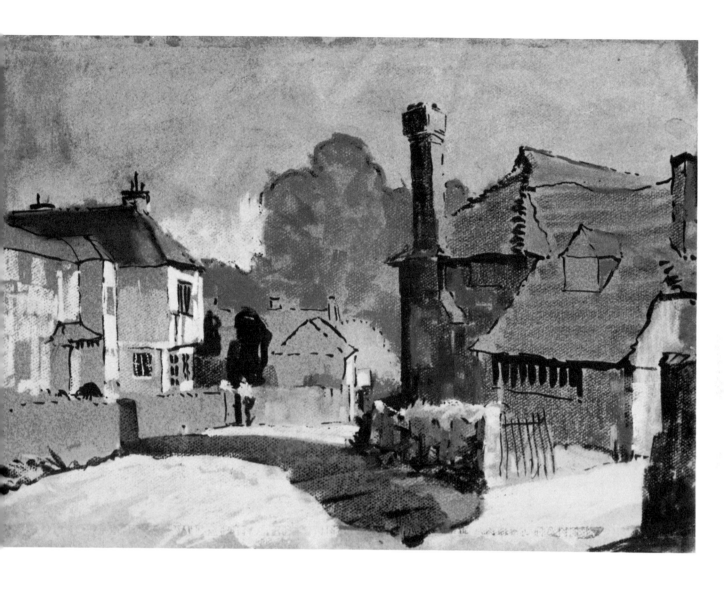

Fittleworth (Stage 2). With an almost-white, light gray pastel, I quickly filled in the sky area with vertical strokes broadly laid down; then, using a small pad of absorbent cotton, I rubbed it into the whole sky. This gave me a lighter tone than the original dark gray paper to work on. The sky had to provide a tranquil backing for the detail of the buildings. So I pressed a very pale purple-gray pastel into the skyline above the figures, taking it up almost as high as the buildings on the left and then blending it with the lightest tone of ultramarine blue. Next, I worked the distant tree mass with gray-green, using purple-gray for the shadow areas. Now I then began to pastel the cottage walls with the palest cadmium yellow, orange, yellow ochre, and raw umber. For the roof, I applied burnt umber to its dark side, and light red where it catches the sun. I rubbed in the umber with my fingertip, for at this stage I was establishing a value in the local color. The dark areas of the chimney and the shaded cottage wall were indicated next. The shadow running over the road was overpainted with broad strokes that permitted the black ink in the grain of the paper to be seen through.

Fittleworth (Stage 3). I now completed a gradation for the sky, lowering the tone as I got to the top. Then I worked in the space between the two buildings, finishing it so that I could more accurately judge the degree of dark that I would require for the roof of the right-hand buildings. You'll notice that I made this space generally darker than the roofs on the left-hand buildings. The purpose of this was to create an illusion of distance between the cottages by virtue of the change in values. Also, notice how the pastel strokes were made on these buildings: their direction either conforms to the structural lines of the buildings or are placed according to their perspective.

Fittleworth (Stage 4). Working outwards, I put the final accents into the lighter areas of the picture to bring out the effect of the morning light and to give contrast to the hazy tree groups in the distance. And here seems a good place to interject a word about windows: take care not to overwork them, or they will look too "starey." Remember, too, that glass picks up myriad reflections from everything around it, so don't work windowpanes with all one color. Also, delineate only enough of them to indicate their form; you don't have to count every one. Keep your final work broad and crisp. For the final step in color, see Plate 29 in the color section.

DEMONSTRATION 6:

Buildings with Water

In Venice, half an hour away by the ferry across the lagoon and away from the glitter of the palazzos and piazzas, is the comparatively primitive island of Burano, famous the world over for its lace. Burano, highly colored and full of character, is a painter's paradise, as you'll discover if you ever have an opportunity to visit it. On the occasion of our visit, my pupils and I walked from the steamer landing toward the center of town, passing the lacemakers at work in the cool of their doorways. Continuing on, we crossed numerous little bridges that span slow-running canals choked with boats of every description, until we came to a pleasant café.

Refreshed from a drink imbibed under a gay sun umbrella, we set to work to capture the mood of this heavenly place. As the easel was set up, my pupils arrayed themselves around me, content to sit in the warm sunshine and let me do the work. I chased them off for ten minutes to collect some visual impressions of this busy scene, for this is the way that their own originality will develop. As I clipped a half sheet of warm gray Canson Mi-Teintes paper to my board, I made my own assessment of the subject; I thought about the pictorial design to be created and the colorful mood to be captured in pastel, and decided that a lively, direct method was required. So I laid in the composition with brown waterproof ink, using a No. 8 good quality sable brush. Then I called back the student group and got down to the work of executing *Café by the Bridge, Burano*.

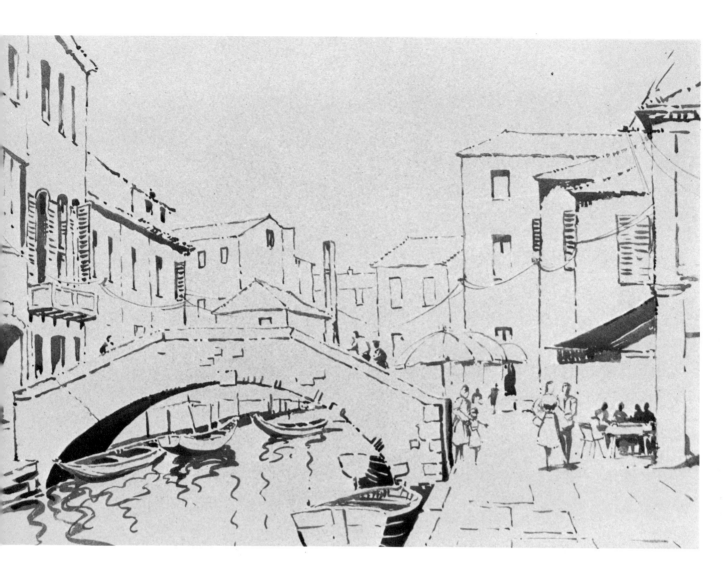

Café by the Bridge, Burano (Stage 1). I made a couple of
layout drafts in my sketchbook of tinted papers, using
brown ink and a No. 8 brush. In these sketches, I set both
the position of the bridge in relation to the café and the
silhouette of the skyline opening above. I expressed the
darks broadly with the brush, and hatched the halftone
areas that were in shade. (Incidentally, you'll find that this
kind of work helps to get the brush working well with the
ink.) Turning to the half sheet of pastel paper—which was a
heavy quality Canson Mi-Teintes pure rag, woven paper in
middle-warm gray, No. 429—I now set in the final composi-
tion with the brown ink, making the most of the ink to
express the darkest passages in the work. As figures moved
into appropriate positions, they were included in the de-
sign; as you can see, they create a balance of interest
off-center and around the sun umbrellas.

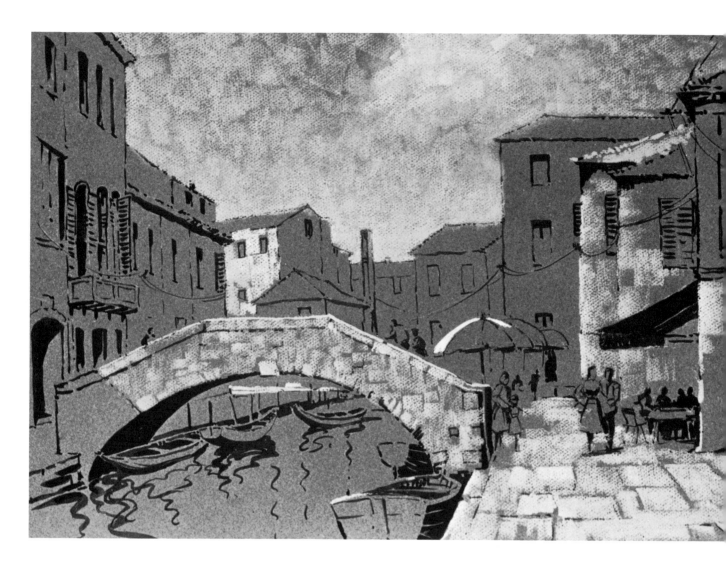

Café by the Bridge, Burano (Stage 2). Comparing the tonal strength of the paper itself with the highly lit areas of the quayside and the sky, I decided that the tone of the paper matched that of the distant buildings in shade above the bridge. I then selected pastels that would represent the highest tonal value of the picture. Because of the blueness in the boats, the sun umbrellas, and some of the building walls that I wanted to accent, I decided to keep blue out of the sky and to use two light tones of purple-gray and the lightest yellow ochre I could find. Since the midday sun was pouring onto the pavement, I used the palest tint of light red for this area. Working with broad, direct strokes, I indicated the skyline above the building with pressure upon the lightest purple-gray pastel. Above this, the slightly darker purple-gray was used to give a feeling of depth and recession to the sky; with the pale yellow ochre, the highly lit, misty clouds were indicated at the top right of the sky. At this stage, all was kept broad and direct.

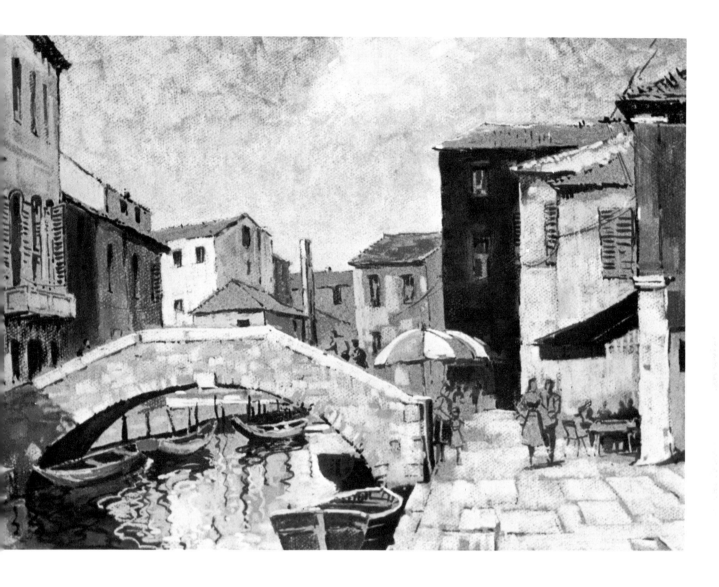

Café by the Bridge, Burano (Stage 3). I now set to work to settle the tonal scale of the picture by pasteling the darkest values under the bridge and the awning. And with grays and gray-greens, I began to work on the darker reflections of the boats and bridge. I didn't interpret the lighter reflections at this time because I wanted to put them in at the same time as I did the buildings that were causing them. However, I made it a point to remember that even the lighter tones of the buildings would appear somewhat darker when they were reflected in the water. Having set the range of tones from dark to light in my picture, I then began to bring it along as a whole. I compared lights with darks as I pasteled the buildings on the left that were in shade. Then I worked on the highly colored brickwork of the bridge. The tall, maroon-colored building (right center) provided a good contrast for the sun umbrellas and the blue buildings in front of it. But I played down the brightness of this maroon building by using a less positive, grayer shade of purple-red so that the umbrellas would become the brightest part of my picture.

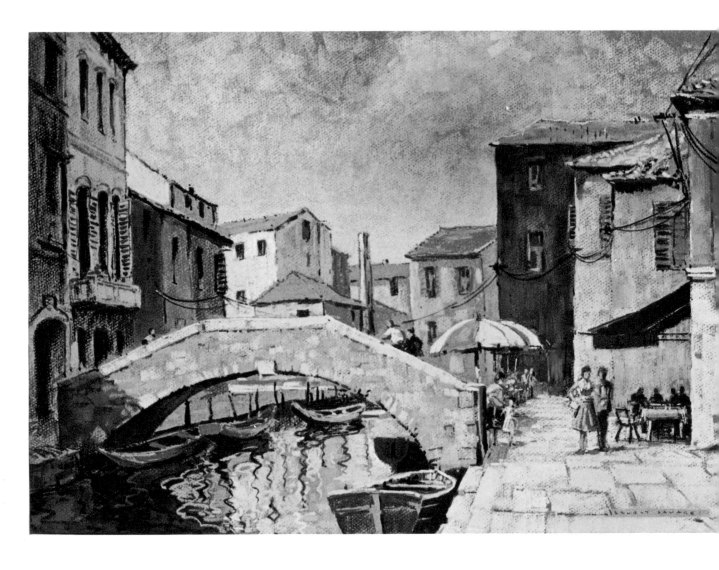

Café by the Bridge, Burano (Stage 4). The only work now remaining to be done was to indicate light and dark accents and to give emphasis to certain aspects of the interesting activity of the scene. (As I've mentioned several times previously, you must always be careful at this final stage of your work not to overdo.) I chose to be bold with the sun umbrellas, the light accents on the figures, the play of sunshine on the quayside under the bridge, and the characteristic looping effect of the electric wires (lighting cables) that I used to assist the composition and to make a play of line that draws the eye into the picture. For the final stage in color, see Plate 30 in the color section.

Marine Subjects in Landscape

What fascination there is for the painter in the exciting bustle of a fishing harbor, with the clutter of trawlers, nets, and tackle; the quayside fishmarkets; and the dwellings of the fishing community. Britain's coastline abounds in such places, and on the Devonshire coast are Sir Francis Drake's homing ports, one of which is Brixham.

Brixham harbor is a horseshoe-shaped inlet that forms a natural harbor; it changes its appearance constantly as boats come and go, tides rise and fall, and squawking seagulls circle overhead. Here are subjects galore for the painter.

Boats are complicated things, never still, but exciting for a town bird like me. They've got individuality, too, for they have the characteristics of the locality where they were built. It's best if we first go around the harbor to sketch and make a number of boat studies. We'll note the special features of the various riggings, superstructures, and hulls so that when an experienced seafarer views our pictures, we won't be subjected to any caustic comments.

As artists, we have to study the water, carefully observing its movement and reflections. Here, again, our old trick comes in handy, for if we squint our eyes, we get a better notion of relative tone values of sea and sky, and of reflections and the objects reflected. We should try for a simplified approach, disregarding unnecessary details to suit our pastel techniques. So put your folding stool by those nets on the quay, breathe in the tang of seaweed and the tarry smell of nets, and I'll show you how *Brixham Harbor* came to be.

Brixham Harbor (Stage 1). Using Canson Mi-Teintes blue-gray paper, No. 431, I began a design layout with brush and black India ink. I placed the main orange trawler off-center, taking care to judge the space required for the reflections that zigzagged with eye-catching brilliance. I worked boldly with the brush, digging into the darks under the bilge of the central trawler and into the shadow it cast on the quay wall. This main dark was extended into the reflections in the water at this point. Finer ink lines were drawn for the headland against the sky, and for the impression of the buildings that clung to the hillside. A single boatman rowing his way to the right disturbed the reflections and picked up light and dark from the distance; this activity in the water movement was used to balance the composition. I left the sky untouched with black ink, but I carefully observed the run of the clouds, trailing out of the picture at top right. Then I very carefully indicated the rigging, masts, lights, signals, and radio lines with brush and ink. (Remember, if a brush-off is required before a second start, ink lines will remain undisturbed and ready for the next attempt.) The figures going about their business on the boats and the quay would be used to link up the over-all design.

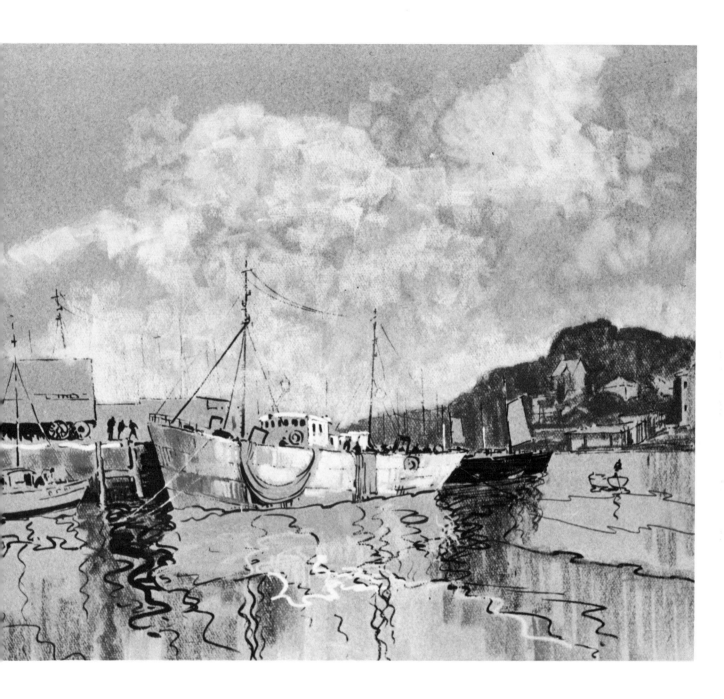

Brixham Harbor (Stage 2). My aim in this next stage was to settle the relative tonal values of the sky and water. So far, a certain amount of lowering (or darkening) of the water value in my sketch had taken place because of the black ink work in the reflections. Thus the water already appeared darker than the untouched sky. So I first brought out the tree-covered headland with firm strokes of a purple-gray pastel. I left the building shapes untouched but, with the same pastel, added dark to the odd window and other simple forms until the waterline was reached. Then I picked out a suitably toned, very pale, lilac gray, and worked this firmly across the distant sky bypassing the dark of the headland, the forest of masts, and the buildings on the quay. I worked next on the sky farther above the buildings, using a slightly darker blue-gray pastel. For the clouds I used the lightest yellow ochre. Leaving the sky in this incomplete stage, I transferred my attention to the lower areas of the water; here I worked in the reflections of the sky with broad, vertical strokes of dark gray-greens, gray-blues, and so on. Finally, I pasteled the orange boat.

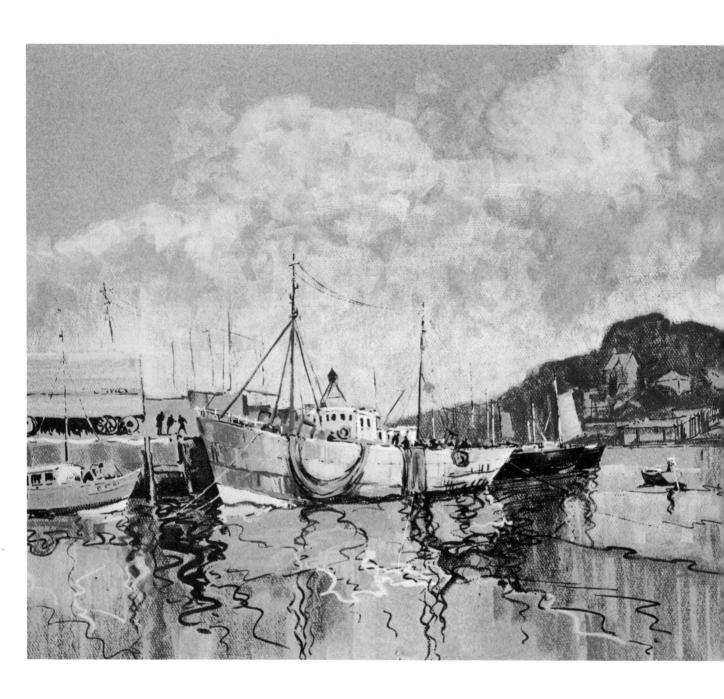

Brixham Harbor (Stage 3). Having obtained in the previous stage the general effect of the tonal values, I now turned to the job of rendering in a broad—and not overdetailed—fashion, the superstructure of the boat and the light on the roof of the wheelhouse. Then with two tints of burnt sienna, I drew the bases of the masts and all the other gear on the deck; their effect in the water was described with lines that followed their movements. Next I worked on the red launch and the loaded refrigerator truck on either side from the center of interest. The greenness of the harbor wall was taken care of with a dark olive-green carried into the reflections in the water. Lighter raw umbers were used for the wall above the launch. Then the boats to the right of the trawler were worked. Now I had a chance to show the flashes of the bright colors of the orange and red floats, and to work their reflections into the water. It was time to return to the sky; a green-blue was used just below the cloud mass while an indigo blue was used above.

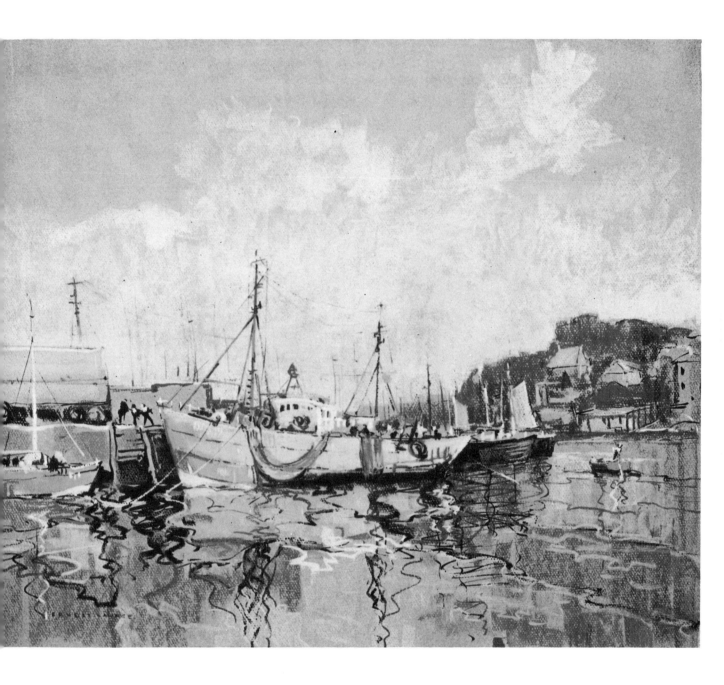

Brixham Harbor (Stage 4). It was now a matter of bringing the whole picture along to its conclusion with more work on the reflections. There were some black ink lines beneath the trawler that I wanted either to modify or lose altogether by working over them with the appropriate pastel. The final touches, after the sky was completed, were to be put into the cluster of masts and stays. I made sure to vary the description of these with different depths of dark gray, so that it would be apparent in the finished sketch that they were at various distances from the eye of the observer of the scene. Quite obviously, I couldn't record every mast and hawser, but an approximate indication of them could be made; this could be done with a hard pastel, if necessary, for the lines would be easier to render with this than they would be with the normal soft variety. In simplifying details of this kind, it doesn't matter what you leave out, for the eye cannot see it all at one glance. That which you do put in, however, must be in the right place as far as structure is concerned. For the final stage in color, see Plate 31 in the color section.

The Indoor Landscape

There are many occasions when weather conditions make outdoor pasteling impossible. For these occasions I keep, as I have over a lifetime of landscape painting, a list of indoor subjects on whick work can proceed in spite of the elements.

It's for this reason that I'm always on the lookout for interesting interiors. Forms, shipwards, castles, churches—in fact, any place that's protected from the weather—can provide wonderful subject material. In a remote village on the Devonshire coast, I discovered an extremely well-preserved blacksmith's forge. It was festooned with a miscellany of antiquated tools and implements, all left just as it was when the blacksmith had stopped pumping the bellows a generation ago. Completely captivated by this most unusual, historically valuable discovery, I traversed the uneven floor of the smithy, working out an angle for a picture. I was so dazzled by the medley of bygones, which fairly shouted to be included in my dream composition, that I scarcely noticed a pair of hand-wrought ox shoes nailed to the rotting door which indicated the great age of the place.

Time was short; so taking the first things at hand—a 20″ x 24″ oil canvas board, and a bottle of brown ink, I set to work with a brush, making as factual a description as possible in the time at my disposal. I then made an effort to commit to memory the general effects of lighting, color, and smithy features that were a must for the picture. I suppose you might wonder why I didn't take a photograph of the place for future reference. Fact is, I didn't think of it! Besides, had I done so, the photo would probably have been more of a hindrance than a help, for it would have constantly reminded me of details best forgotten. So, relying on memory and the quick sketch I did on the premises, here's how I went about recreating *The Old Forge, Wembury*.

The Old Forge, Wembury (Stage 1). Examining the original sketch (*Figure* 55) on my return, I found the forge chimney to be too centrally placed, and decided to add features that would extend the picture to the right. I carefully traced my original sketch with a colored fiber-tipped pen then, after rubbing strong yellow ochre pastel onto the back of the tracing, I taped the drawing to the left of a 20" x 26" rectangle. These dimensions gave me what I was after—an additional 2" for extending the picture to the right. The composition was worked on a very dark brown, good quality pastel paper, and the yellow-ochre tracing came through good and clear. The right-hand extension of the layout was directly drawn in with a yellow ochre hard pastel. Now I was ready to contemplate the pastel work to come. The smithy was lit by the windows and a doorway to the right, which created a darkness in the area behind the forge. I quickly rubbed in some suitably toned pastel to begin the lighting effect I had in mind, and then put the work aside. I needed time to consider further execution.

The Old Forge, Wembury (Stage 2). The greatest problem involved in a subject of this kind is adequately to play down details, yet leave the impression that nothing is left out. Tools and equipment have to be sorted into groups, linked together in their shade, and yet be seen individually through those parts of their structures that catch a sparkle of light. As might be expected, this whole building at Wembury reeked of rust, dust, and decay, though it had possessed an atmosphere of warmth. Since I wanted all this to come through in the picture, I began to work with various brown tints—very light ones to pick out the stone-built chimney, and darker ones for the mystery behind it. Up in the dark ridge of the roof, I used purple-grays, purple-browns, and sepia extensively. At this stage I was careful to preserve a good portion of the dark tobacco brown of the original paper, for I planned on having this work for me.

The Old Forge, Wembury (Stage 3). The picture was now
getting exciting. I developed more light from the outside,
and gave effect to the sill of the brightly lit window, which
was loaded with harness tackle. You'll see where I have
stroked some implements that caught the light with firm,
directly applied lines to describe the character of the odd
objects. I did more work to the rusted cooling tank stand-
ing before the furnace, then worked round the darks to the
left of this to bring out the anvil, typically planted on the
stump of an old oak tree. Adjacent antediluvian machinery,
like the old wheeled lathe, now began to emerge, and I
touched upon the muddle of nail boxes and key racks in
the recess at the immediate left. After a squint and more
deliberation, I added a little more color to a higher value
and warmer temperature over the rubbed effect of light on
the floor that I'd put in at the start.

The Old Forge, Wembury (Stage 4). First I brushed off the horizontal tie beam, which I'd inadvertently placed in front of the chimney. Then I repasteled, where necessary. Then—back to the window lights. I described the glazed old metal bars, and added a little more cool light coming through the dusty glass. I made sure that each part of the structure seen against the light was of a dark tonal value. Following this, I gave a little more character to the hood of the furnace, and let some of the old roof timbers fade away into shadows of dark-toned browns and grays. I gave a little more emphasis to the group in the lower right-hand corner, but kept it understated and somewhat out of focus, so that attention would focus on the area around the forge itself. Accents of half lights on the implements on the left were then put in. At this point, I placed the frame over the work (see Chapter 6) to see whether there was much more that needed to be done. I discovered that I was satisfied. For the final stage in color, see Plate 32 in the color section.

8. Studio Activities

Earlier, I described to you how my studio is set up for working with pastels. But after pasteling, you have to deal with matting, framing, storing, and exhibiting your successful pictures. Here's how to organize yourself for all this.

There are no real problems in framing pastels, so long as you go about it the right way. Some artists like to "frame up" with the surface of the pastel touching the glass. This is chancy, for if there should be even the slightest wrinkling of the paper, any pastel particles adhering to the glass will throw unpleasant shadows into the hollows. In the long run, it's best to frame a pastel picture in such a way that it stands clear of the glass. This way, it will retain the characteristic bloom of the technique.

There are two ways to make sure that the picture doesn't touch the glass: (a) place the picture under a thick mat before it's framed; (b) place a narrow strip of wood into the rabbet (rebate) of the frame between the glass and the picture. Obviously, to frame a picture pasteled on paper by this second method, you first have to mount it (paste it down) on a piece of cardboard; this keeps the picture taut and away from the glass.

The size of your work will largely determine whether you should mat it or close-frame it. When a picture is framed without a mat, we call it close-framed; this is the normal way to frame an oil. If you do a pastel on a full sheet of imperial-size (22″ x 30″) paper and then give it a 5″ wide mat, you end up with an enormous, very heavy picture. I always close-frame my full-sheet pastels.

One advantage in using a mat, much in the way that you would frame a watercolor, is that pictures up to half-imperial-size (15″ x 22″), pasteled on heavy quality paper, can be matted as they are. Pastel worked on the lighter-weight charcoal papers, or on papers of any size over half imperial, have to be mounted on cardboard first. It pays to be particular about the way you present your work. To give your pictures the longest possible life, never skimp on the framing and the work it entails. No matter what the size, all my pastel work is mounted on 12-sheet white cardboard of the finest quality. But I prefer pasteling on papers

before they're pasted down on cardboard. People exclaim with some concern, "But isn't that a risky business? Mightn't you smudge it?", and so on. But if you go about it the right way, there's no risk at all.

Mounting pastel pictures

As a general rule I don't fix my pastels; I have a theory that, since the paper on which a pastel is worked is always quite damp when I paste it down, some of the paste will work its way through the paper and stick to the backs of the pastel particles. Anyhow, let me explain how I mount, that is, paste a pastel picture on cardboard.

As I said in the opening chapter, pastel pictures will stand a lot of wear and tear. So, first of all, don't be nervous about mounting them; start this task with confidence. You need to be well prepared at the start, with a tabletop or two cleared for action. All the materials for this operation should be at hand before you begin; for this reason I always have a pasting session, when I do about a dozen pictures at one time. This saves an enormous amount of time in setting up the studio for the actual job. I'll describe how you prepare.

First, mix a half bucket of paste and let it stand overnight. Wallpaper paste (Polycell in Britain) is ideal to use. Or you can mix up an ordinary flour paste; just be sure to use very hot water with flour.

On "P" day, collect a heap of newspapers—at least four sheets for every picture being mounted.

Now, cut a piece of thick, best-quality white cardboard for each picture. The cardboard should be an inch or two bigger all around than the picture that's to be mounted on it.

Next, cut sheets of thin brown paper for pasting on the backs of the cardboards to counteract the pull of the pictures on the front. This will keep the pieces of cardboard flat. Cut the brown papers to the same size as each picture.

Always keep two 4″ housepainters' brushes handy—one for paste and one for water. Also have a cloth for rubbing down; a piece of hardboard or Masonite, larger than any of the pictures, to put on the floor; and last, a large drawing board and a number of large, heavy books to be used as weights.

As we proceed, you'll see the point of mounting a good many pastels at one time.

Procedure for mounting

First, put the picture, pastel downwards, on a sheet of newsprint. With a large brush, moisten the back with water. Don't have the brush sopping wet; but do make sure that the entire paper is dampened. This will cause it to stretch while you do the next task.

Next, on another table, paste a sheet of thick white cardboard, finishing the

pasting with strokes that go the full length and width of it. This will ensure an even spread of the paste.

Now, using two hands, take the pastel painting and lower it, damp side down, onto the pasted surface of the cardboard. Cover the pastel with a fresh sheet of newspaper, and with the cloth, rub with a circular motion from the center out to the corners. Don't be afraid of putting pressure on the newspaper; just be sure that it doesn't slide as you rub. Actually, the newspaper should hold itself in place, because the pasted cardboard is bigger than the picture; therefore the newspaper should attach itself to the pasted margin of the cardboard that extends beyond the picture.

This is the moment to check to see that all is going well and that there are no wrinkles in the picture. Then discard the newspaper, wipe the margins free of paste, and cover the picture with a fresh sheet of newspaper. Now you're ready for the next step.

Turn the newspaper-covered picture upside down, and paste the *back* of the white cardboard. When you've finished putting on the paste, put a sheet of brown paper over it, rubbing the paper as you do so.

Another sheet of newspaper should now be put behind the pastel so that the pastel is protected with newspapers on both sides. Lay it, still sandwiched between the newspaper sheets, on the Masonite sheet, and cover it with the drawing board. Do this with each picture, stacking one on top of the other as you proceed, transferring the drawing board to the top of the stack each time you add another picture. Finally, weight the drawing board with the large books, and let the whole thing stand overnight.

The next day you'll be happy with the results. Change all the protective newspapers to fresh ones, and leave the pastels to dry out properly under the drawing board—but without weights—before matting or framing them.

Retouching

You can expect to lose a little of your pastel during the process. But so long as you haven't allowed the protective papers to slide against the pastel surface and cause smudges, you won't notice any real difference in your work as a result of mounting it. Once it's perfectly dry, you can touch up the job, or make final alterations before framing. This is the grand thing about pastels: they are so easy to correct, or to restore. If you do any extra work with pastels after they've been mounted, remember to give the work a few taps to remove any loose particles before framing.

Prepared boards versus pastel papers

You may think that all this work of mounting finished pictures is a waste of time and energy, and prefer to take the easy way out by using pastel papers already

mounted on boards. Briefly, the pros and cons of pasteling on prepared boards are these: Although time is saved in their use, a great deal of the texture bite goes out of the pastel paper as soon as it's mounted. This is the chief disadvantage of prepared boards. Another is their cost, since not all the work we do will be successful. Last, using boards exclusively will limit the variety of lovely makes and colors that are available to you in papers. On the whole, it's sensible to make use of both boards and paper, depending on the purpose of the job.

Fixing pastels

As I've said, my pastel pictures remain unfixed—that is, I don't squirt them with any aerosol fixative. These modern fixatives are quite satisfactory for charcoal or hard pastel drawings. However, they don't really fix a soft pasteled picture in the sense that after using it, you can rub your hand across its surface without disturbing it.

If you're going to store a picture, there's no harm done in giving it a spray of fixative prior to attaching a protective sheet to it. Undoubtedly, though, the best way to preserve a pastel is to frame it under glass. Incidentally, I still prefer polished glass, despite the disadvantages of its mirrorlike surface, to the nonreflective kind that tends to make the work look more like a reproduction.

I've had some of my pastel pictures heat-sealed. This is a process that lays a permanent, thin protective sheet over the work. I don't care for this either, for the original appearance is lost and the lovely pastel bloom is gone forever. Moreover, the painting can never be touched up or restored.

Storing pictures

I keep mine, each with a protective sheet, in the drawer of a plan chest. Pastels will keep well in portfolios, but you must always use some protective covering. Remember that pastels, like watercolors, will suffer from damp conditions. So keep yours in a dry place, and from time to time, take them out for viewing; this will also give them an airing.

Exhibiting pastels

No matter what personal standards you set for your work, it's good to subject your pictures to the test of the public gaze. Make it a habit to submit your work to exhibitions, whether they be local, state, or national ones. This provides extra incentive, and although we all occasionally have to suffer the disappointment of having our work rejected, acceptances can indicate progress and make us feel wonderfully encouraged.

Having served on many panels that selected pictures for exhibition, I can tell you that there are three main reasons for rejects: (a) poor presentation and

unsuitable framing; (b) commonplace subject material and immature technique; and (c) lack of sincerity.

Although much is said about the competence of selection juries after the event, I can assure you that the professional will quickly detect if the would-be artist is sincere or not. In the long run, stunts and gimmicks always lose out.

The Pastel Society, Great Britain

It may interest you to know something of this unique institution, which is the oldest in the world devoted exclusively to the pastel medium. Founded in 1880, the Pastel Society continues to hold annual open exhibitions in London. Many master artists of the past have been members and exhibitors, including the Royal academicians Sir Frank Brangwyn, Sir George Clauson, John S. Sargent, J. McNeill Whistler, and George Watts.

The exhibitions of the Pastel Society are held in the galleries of the Federation of British Artists, Carlton Terrace, Pall Mall, London, W. 1. If you're having success with your work in America, why not write to the secretary at this address? He'll give you details covering the submission of work and application for membership. After all, a pastel can be sent in a cardboard tube, to be framed by a London exhibition agent. For very little expense, you can have a picture hung in the Pastel Society's exhibition. If you want to have a go at this, write to: Green and Stone, Limited, Exhibition Agents, 259 Kings Road, Chelsea, London, S. W. 3. They're the ones with whom you should make arrangements for the framing, submission, and eventual return of your work. Of course, it could very well be sold. What excitement!

Organizing your studio

It certainly pays to be as orderly as your nature permits, so that everything is always at hand for your artwork. This is especially important with pastel, for if you get good and properly bitten by the pastel bug, you'll accumulate no end of materials, and box upon box of pastels. Keep the checklists going, and with the help of charts, maintain a stock of those pastels you quickly use up. Have places to hang suppliers' catalogs, sample papers, and an account of incidental expenses. Your tax man may be less suspicious than mine, but in the end, accuracy in this connection will be worth it.

Photographic studio aids for the landscape painter

Although I maintain that the true landscape painter must be constantly observing and sketching from nature, you can assist your visual memory by making reference collections to keep in your studio. The most obvious of these is pictorial matter, either reproductions, picture postcards, photographs, or color transparen-

cies. Providing you accept the fact that these aids can never be equal to the real thing, there are times when such references can be very useful. Last year, for example, I was commissioned to paint a picture of the whole harbor at Monte Carlo, including the palace of the principality, the Onassis yacht, and literally hundreds of smaller boats. For this I just had to have photographic help, since my client wouldn't foot the bill for a few months' stay on the French Riveria!

Color transparencies really have only a limited use, for generally the artist prefers to be selective with his compositions and to do a certain amount of rearrangement to suit his purpose. But for those who, unfortunately, are confined to their homes for any reason, landscape painting from pictorial material is their only way, and much happiness can result through purposeful work by this means.

Models as studio aids

Very exciting pictures can be developed by building mockups of landscapes, using toys and models. Realistic farm animals, houses, boats, and so on, combined with rock specimens, sand, and gravel can be used to good effect. Use moss or sponges for trees; mirrors and glass for ponds; stick up some backdrops for skies, and you have the makings of a composition. Be sure to use one light source.

My studio is cluttered with all kinds of mementos. It becomes more and more like the prop department of a movie studio. At rest under the fir trees in my studio garden, which backs on to open pastures and hilly woodlands, I have an original, century-old, four-wheeled wagon like the one in Constable's *Hay Wain*. All things of this kind stir the imagination of the many pupils who pass through my studio workshops, and the old wagon is a challenge for them to draw.

It's generally agreed that, at the start of a landscape painting, there must always be present in the artist a feeling of excitement which motivates his task. My studio trappings help to stimulate this excitement, whereas too much recourse to printed or photographic references can be deadening.

Copying reproductions

Some beginners do a lot of copying, which, at best, can only help them with color-matching and application. If you're completely inexperienced, you can increase your technical knowledge in this way, and perhaps become more confident when doing original work. My demonstration sequences are designed to help you tackle similar subjects; so, for a while, lean on my particular approach to pastel painting. There are many approaches; mine is only one. In the end, you should try and develop your own.

Have you ever seen a master copier at work? I had this fascinating experience last year, when I was invited to Murthley Castle in Scotland to see the American artist Adrian Lamb painting a facsimile of an extremely large, unusual oil painting for a national art museum. Here was a master craftsman in this particular

field at work. Two 10-foot canvases stood in a superb banqueting hall, spotlighted from a hammer-beamed roof. They were likes peas in a pod. I don't believe Jacob Miller, who painted the original in 1830, could have said which was which. This early American work depicted the meeting of one of the ancestors of the castle's owners with a tribe of Indians. I was lost in admiration of Lamb's technical genius, acquired over a lifetime of copying masterpieces from the world's most famous galleries. We exchanged art talk, and later, when we were sitting together in a limousine that was transporting us to a high tea in another wonderful castle home, Adrian turned wistfully to me and said, "You know, I envy your being able to paint so frequently from nature." He went on to recall a highlight in his life that occurred in 1928, when he did some watercolor sketching at Amberley, Sussex. How strange it is that the invisible cords of life draw similar people together—for my own studio is but a short walk to this most lovely English village that Lamb sketched. I've sketched it for you in Figure 14.

This incident should help stress the importance of continuous work on location. There's nothing better that you can do to improve your knowledge of landscape and the moods of nature.

Final thoughts

We've certainly had an interesting journey together since the opening chapters. Flipping through the manuscript, I wonder if enough encouragement has been given to those embarking on this new pursuit. Pastel is an exciting medium, and I hope some of my unbounded enthusiasm for it will infect you. Once you've made a start with it, you'll realize its potential and be thankful for the easy freedom with which pastel can be developed.

I think the final advice given to my pupils at the end of my pastel-painting courses it worth repeating here. First, aim for *direct* expression with simplified statements, and avoid overdetailed work. Second, *think* before you pastel. Third, when your picture is not going well, don't panic and overload the pastel. Be prepared to *brush off* and to *repastel* frequently, for this is so *easy*.

Happy pasteling!

Appendix

The following has been compiled to provide you with a handy reference for supplies of certain materials and equipment made especially for pastel. Clearly, this information can't be exhaustive. For a complete list of requirements, you could do no better than to obtain a copy of the Artists' Guide which is published annualy in *American Artist*. No artist should be without this. My thumbworn copy is a part of my bedside anthology.

To begin, I've listed the addresses of suppliers. However, most art supply stores and some large stationers carry their products, so unless you have no access to these places, I doubt if you'll find it necessary to contact the suppliers directly.

Addresses for suppliers

Anco Wood Specialties, Inc., 71-02 80th Street, Glendale, N.Y. 11379

Charles T. Bainbridge's Sons (Cardboard), 20 Cumberland Street, Brooklyn, N.Y. 11205

Bee Paper Co., 100 8th Street, Passaic, N.J. 07055

Crescent Cardboard Co., Dept. A-2, 1240 No. Holman Ave., Chicago, Ill. 60651

M. Grumbacher, Inc., 460 W. 34th St., New York, N.Y. 10001

Strathmore Paper Co., 200 Park Ave., New York, N.Y. 10017

Swan Pencil Co., Inc., 221 Park Avenue So., New York, N.Y. 10003

Talens and Sons, Inc., 10 Rio Court, P. O. Box 453, Union, N.J. 07083

Windor & Newton, Inc., 555 Winsor Drive, Secaucus, N. J. 07094

Boards, Charko

Crescent Cardboard Co.

Courses, home

The Ernest Savage Pastel Course. An inexpensive introduction to the pastel medium. Comprehensive course of lessions includes fine kit of materials. Obtain

color brochure from: Pitman Correspondence College, Park Street, Croydon, England. CR9 3NQ.

Designers' gouache

M. Grumbacher; Talens and Sons, Inc.; Winsor & Newton, Inc.

Easels

Anco Wood Specialties, Inc.; M. Grumbacher, Inc.; Winsor & Newton, Inc.

"The Sussex Easel," mentioned in the text, is obtainable from Duncan-Vail Co., Los Angeles, California.

Pastel papers

Charles T. Bainbridge's Sons; Bee Paper Co.; M. Grumbacher, Inc.; Strathmore Paper Co.

Samples of Canson papers can be obtained from The Morilla Co., Inc., 43-01 21st Street, Long Island City, N.Y. 11101.

Pastel Pencils

Carbo-Othello, from Swan Pencil Co.

Pastel manufacturers

Space allows only the inclusion of the full assortment of soft pastels for artists by two leading manufacturers, M. Grumbacher, Inc., and Talens and Sons, Inc. At the time of publication the fine and extensive range of colors on the following lists were available.

GRUMBACHER

COLOR	Item No.	Perma-nency	PURE COLOR	WHITE ADMIXTURE				BLACK ADMIXTURE	
				15% F	40% H	60% H	80% M	40% A	15% C
Black	92	***	1	-	-	-	-	-	-
Bluish Violet	41	**	2	2	1	1	1	2	2
Bordeaux	100	***	2	2	1	1	1	2	2
Burnt Sienna	26	***	1	1	1	1	1	1	1
Burnt Umber	28	***	1	1	1	1	1	1	1

COLOR	Item No.	Perma-nency	PURE COLOR	WHITE ADMIXTURE				BLACK ADMIXTURE	
				15% F	40% H	60% H	80% M	40% A	15% C
Cadmium Orange	9	***	3	3	2	2	2	3	3
Cadmium Red, Light	17	***	3	2	2	1	1	2	3
Cadmium Red, Medium	18	***	3	2	2	1	1	2	3
Cadmium Red, Deep	19	***	3	2	2	1	1	2	3
Cadmium Yellow, Deep	8	***	3	3	3	2	2	3	3
Caput Mortuum, Deep	23	***	1	1	1	1	1	1	1
Carmine Red	38	**	3	2	1	1	1	3	3
Chrome Green, Light Shade	62	**	2	2	1	1	1	2	2
Chrome Green, Deep Shade	63	**	2	2	1	1	1	2	2
Deep Ochre	15	***	1	1	1	1	1	1	1
Deep Violet	42	**	3	2	2	1	1	2	3
English Red	20	***	1	1	1	1	1	1	1
English Red, Deep	21	***	1	1	1	1	1	1	1
Flesh Ochre	16	***	1	1	1	1	1	1	1
Gold Ochre	95	***	1	1	1	1	1	1	1
Greenish Blue	50	**	3	2	1	1	1	2	2
Gray	90	***	1	1	1	1	1	-	-
Gray Blue	51	***	1	1	1	1	1	1	1
Greenish Gray	61	**	1	1	1	1	1	1	1
Indigo	52	***	1	1	1	1	1	-	-
Lemon Yellow	13	**	2	1	1	1	1	2	2
Light Ochre	14	***	1	1	1	1	1	1	1
Madder Lake	31	**	3	2	1	1	1	3	3
Moss Green	69	***	3	2	1	1	1	3	3
Mouse Gray	55	***	1	1	1	1	1	1	1
Olive Green	70	**	2	1	1	1	1	1	2
Permanent Green, Light	104	**	3	2	2	1	1	2	2
Permanent Green, Deep	68	**	2	2	1	1	1	2	2
Permanent Red # 1	32	**	2	1	1	1	1	1	2

COLOR	Item No.	Perma- nency	PURE COLOR	WHITE ADMIXTURE				BLACK ADMIXTURE	
				15% F	40% H	60% H	80% M	40% A	15% C
Permanent Red, Light	33	**	3	1	1	1	1	2	2
Prussian Blue	47	**	3	3	2	1	1	-	-
Purple #2	39	**	3	3	3	2	1	3	3
Raw Umber	27	***	1	1	1	1	1	1	1
Red Brown Ochre	99	***	1	1	1	1	1	1	1
Sunfast Thio Violet	105	**	3	2	2	1	1	2	2
Sunproof Yellow	5	**	2	2	2	1	1	2	2
Ultramarine Blue, Light	45	***	2	1	1	1	1	2	2
Ultramarine Blue, Deep	46	***	2	2	1	1	1	2	2
Viridian (Vert Emeraude)	60	***	3	2	2	1	1	3	3
White	1	***	1	-	-	-	-	-	-

NOTE: The numbers under A,C,D,F,H,K,M indicate price groups per box of six sticks. Price group #1 ($2.40), group #2 ($3.60), and group #3 ($4.80). Prices subject to change. Asterisk symbols: one means good, two mean excellent, and three mean absolute permanency.

Rembrandt soft pastels.

In common with many of the world's leading pastel manufacturers, Talens in 1971 reduced the number of colors in their range of Rembrandt soft pastels. I assisted the manufacturers in their final choice of 150 tints, which forms an efficient and comprehensive assortment. The full range of the new Rembrandt assortment is as follows:

TALENS AND SONS

COLOR	ITEM NO.	SHADES				
White	100		5			
Light Yellow	201	3	5	7		
Deep Yellow	202	3	5	7		9
Lemon Yellow	205	3	5	7		9
Yellow Ochre	227	3	5	7		9
Gold Ochre	231	3	5	7		9
Raw Sienna	234	3	5	7		

COLOR	ITEM NO.	SHADES				
Orange	235	3	5	7		9
Carmine	318	3	5	7	8	9
Alizarin Crimson	331	3	5	7	8	
Caput Mortuum Red	343	3	5	7	8	9
Indian Red	347	3	5	7		
Deep Rose	362	3	5	7	8	9
Permanent Red, Light	370	3	5	7	8	
Permanent Red, Deep	371	3	5	7	8	9
Raw Umber	408	4	5	7		9
Burnt Umber	409	3	5	7	8	9
Burnt Sienna	411	3	5	7	8	9
Ultramarine Blue, Deep	506	3	5	7		9
Prussian Blue	508	3	5	7	8	
Cobalt Blue, Medium	512	3	5	6		9
Violet	536	3	5			
Mars Violet	538	3	5	7	8	9
Red Violet, Light	546	3	5	7	8	
Red Violet, Deep	547	3	5	7		9
Blue Violet	548	3	5	7	8	
Phthalo Blue	570	3	5	7	8	9
Chrome Green, Light	608	3	5	7		9
Chrome Green, Deep	609	3	5	7	8	9
Permanent Green, Light	618	3	5	7	8	9
Permanent Green, Deep	619	3	5			
Olive Green	620	3	5	7	8	
Blue Green	640	3	5	7	8	9
Phthalo Green	675	3	5	7	8	
Black	700		5			
Gray	704	3	5	7	8	9
Mouse Gray	707			7		
Blue Gray	727	3	5	7	8	9

Bibliography

Books on pastel

Merriott, Jack, *Drawing and Painting in Pastel*. Princeton, N. J.: Van Nostrand Co., 1964.

Richmond, Leonard, *Fundamentals of Pastel Painting*. New York: Watson-Guptill Pubs., 1970.

Savage, Ernest, *Pastels for Beginners*. New York: Watson-Guptill Pubs., 1966.

Sears, Elinor L., *Pastel Painting Step-by-Step*. New York: Watson-Guptill Pubs., 1968.

Werner, Alfred B., *Degas Pastels*. New York: Watson-Guptill Pubs., 1968

General books

Fabri, Ralph, *Painting Outdoors*. New York: Watson-Guptill Pubs., 1969.

Pitz, Henry C., *Ink Drawing Techniques*. New York: Watson-Guptill Pubs., 1957.

Watson, Ernest W., *Composition in Landscape and Still Life*. New York: Watson-Guptill Pubs., 1959.

White, Gwen, *Perspective: A Guide for Artists, Architects and Designers*.
New York: Watson-Guptill Pubs., 1968.

Index

Edited by Heather Meredith-Owens
Designed by James Craig
Printed and bound by Halliday Lithograph Corp.
Color printed by Algen Press